IMAGES
of America

MARITIME OLYMPIA
AND
SOUTH PUGET SOUND

IMAGES
of America
MARITIME OLYMPIA
AND
SOUTH PUGET SOUND

To Steve. Karen joins me in the hope you'll enjoy the page

Les Eldridge and John W. Hough

ARCADIA
PUBLISHING

Published by Arcadia Publishing
Charleston, South Carolina

Printed in the United States of America

Library of Congress Control Number: 2016953990

For all general information, please contact Arcadia Publishing:
Telephone 843-853-2070
Fax 843-853-0044
E-mail sales@arcadiapublishing.com
For customer service and orders:
Toll-Free 1-888-313-2665

Visit us on the Internet at www.arcadiapublishing.com

*To the master mariners who plied South Puget Sound and to
the late Robin Paterson, longtime president of the International
Retired Tugboat Association, who spent a lifetime preserving the
memories of Puget Sound tugs and Mosquito Fleet steamers*

CONTENTS

ACKNOWLEDGMENTS

We thank the many helpful professionals at the following institutions who provided us with information and guided us in locating many of their photographs in this book: Port of Olympia; Museum of History and Industry, Seattle (MOHAI); Olympia Tumwater Foundation; Tacoma Public Library; University of Washington Libraries, Special Collections; and Washington State Archives. We also cannot thank enough Deborah Haskett, who generously gave us access to the personal collection of historic maritime photographs assembled by her and her late husband, noted marine artist Patrick Haskett, and Kae Paterson, who graciously shared with us her late husband Robin's extensive photograph collection of anything that floats.

We tip our hat to Chuck Fowler, award-winning Northwest maritime historian and author of several Arcadia books, for guiding us along the way, and to Patrick Eldridge, of Seattle Media Lab, who lent his graphic and computer skills to his dad's project. Also, this book only came together with the invaluable advice and counsel of our ever-patient editor Henry Clougherty at Arcadia. We also thank the production staff at Arcadia for turning our poor efforts into this wonderful book.

We cannot go without extending our thanks to our wonderful wives, Mary Eldridge and Cindy Hough, for their loving patience and support throughout this project. We could not have done it without you.

All photographs in chapters 4 and 5 are courtesy of Port of Olympia unless otherwise noted.

INTRODUCTION

Olympia, Washington state's capital, is located at the southern tip of Puget Sound.

This inland sea was carved out during the last ice age by a massive ice sheet that left a deep basin when it retreated. The entry into South Puget Sound is a narrow channel of swift currents between Tacoma and the Kitsap Peninsula that opens into a string of emerald islands leading up the sound to Olympia. The capital city has grown into the major port for southwestern Washington, but for millennia before Anglo-European explorers, traders, and settlers arrived, the resource rich waters of South Puget Sound had been home to Coast Salish people.

The indigenous people of South Puget Sound were accomplished voyagers. They used canoes carved out of huge cedar trees to fish for salmon, travel to prized clam and oyster beaches, and trade among themselves and with their Coast Salish neighbors to the north.

The first Europeans to encounter these intrepid mariners were British captain George Vancouver and his naval expedition in May 1792. Vancouver anchored near the future site of Seattle and sent 2nd Lt. Peter Puget, sailing master (navigator) Joseph Whidbey, and naturalist Archibald Menzies south of the Narrows to chart the unknown inlet. They failed to find a possible passage across the continent but in exploring the winding passages among the islands created detailed charts of the inlet. Vancouver honored Puget by naming the southern inlet Puget's Sound.

The British continued to explore the region. In November 1824, a 48-man Hudson's Bay Company (HBC) brigade ventured north from Fort George (later Astoria) on the Columbia River. As a result of its trip through the resource rich area, HBC established Fort Nisqually, the site now inside today's town of DuPont. The HBC outpost became a major trading center for South Puget Sound.

Americans first arrived in 1841 with the US Exploring Expedition, commanded by US Navy lieutenant Charles Wilkes. He and his men created very detailed charts of the South Sound and placed numerous names on geographical features in the sound, including the names of two of his officers: Olympia's Budd Inlet (Lt. Thomas Budd) and adjacent Eld Inlet (Midshipman Henry Eld). His detailed charts and naming in the sound were factored in the international boundary being set at the 49th parallel in the 1846 negotiations between the United States and Great Britain.

An extraordinary assembly of seagoing scientists accompanied these early visits to South Puget Sound. George Vancouver's naturalist and physician, Archibald Menzies, collected many plants and named the Pacific Northwest's ubiquitous Douglas fir after his colleague David Douglas. Scientists affiliated with the Hudson's Bay Company enhanced the world of botany and zoology. The Wilkes Expedition included 11 scientists whose specimen collections around the world from 1838 to 1842 caused the Smithsonian Institution to build its iconic "Castle" to house many thousand items of science.

These hardy, venturesome explorers and traders opened wide the door to South Sound settlement. Americans settlers began flowing into Oregon country, eventually displacing the HBC. In 1853, Oregon became a state, Washington Territory was created, and Olympia named its capital.

Thick, verdant forests ringed Puget Sound. In the absence of roads among communities, a marine transportation system evolved, beginning in the 1850s and not ending until the advent of the automobile and decent roads in the 1920s. Hundreds of small steamships moved goods and people among the villages and towns along the sound. Olympia was the southern terminus of the web of steamship routes that extended to every corner of the inland sea.

The small steamers churning and buzzing around Puget Sound earned the title "Mosquito Fleet." Colorful, competitive captains raced at every opportunity, striving for reputation as the fastest boat along the water highway. Owners engaged in "rate wars," undercutting each other's prices to gain a bigger share of the passenger market. Propelled initially by stern-wheel and side-wheel paddles and later by screw propellers, the Mosquito Fleet engendered the construction of docks, shipyards, and navigation-dependent businesses. These vessels were the splendid vehicles on the Puget Sound and still live vividly in the memory of old-timers.

Sailing cargo vessels and Mosquito Fleet steamers served a growing Olympia, but mudflats that pushed out into Budd Inlet deterred larger oceangoing steamers from calling at the capital city. At the turn of the 20th century, extensive dredging deepened the harbor and created new uplands to provide a practical ocean-wide outlet for local goods.

Timber products were, and are today, a major portion of the Olympia area's economy. By 1922, there were 30 lumber mills, five shingle mills, and a veneer plant on the shoreline near Olympia. In addition, local farms grew a wide variety of berries, which were canned for shipment. Olympia Beer, brewed in nearby Tumwater, and succulent Olympia oysters were also shipped to customers worldwide.

To boost commerce, in 1922, the voters of Thurston County created the Port of Olympia, and the business promptly began building piers along the newly filled area. Oceangoing steamers soon began calling on Olympia. In 1927, ninety vessels tied up to the port's docks. In the early 1930s, new port facilities were built under President Roosevelt's New Deal. During World War II, the port shipped large amounts of lend lease equipment and material to Russia.

After the war, Budd Inlet became home to a naval reserve fleet of mostly freighters, which existed until 1972. During the Korean War, the port began a long relationship with nearby Fort Lewis, shipping men and equipment to the Far East and then other conflicts around the world.

During the 1950s, lumber shipments continued as the port's mainstay cargo. In 1956 alone, 161 million board feet of lumber were shipped. Two gantry cranes were installed in the early 1960s to expand the range of cargo handled.

The 1970s saw the growing use of containers to transport cargo aboard ships. While larger Puget Sound ports such as Seattle and Tacoma rebuilt themselves to handle containers, the Port of Olympia focused on cargos not suitable for containers. Lumber shipments remained a major focus, with log exports accounting for 98 percent of the port's maritime business in that period. But the port continued to expand its market by handling a wide range of cargo, as it does today.

As container ships became the standard means of transporting ocean cargo, the Port of Olympia continued to carve out a niche focusing on cargos that do not easily fit into boxes. Timber shipments remain the core of the port's business. But the port handles a variety of other types of cargo. Also, the port continues its close relationship with nearby Fort Lewis, now part of Joint Base Lewis-McCord, handling shipment of military vehicles and supplies around the world.

Historically, much of South Puget Sound was a marine highway for transporting people and goods. But as Olympia and the surrounding area grew, recreational boating emerged as an important contributor to the region's economy. Budd Inlet is home to several private marinas and one operated by the Port of Olympia. The Olympia Yacht Club was formed in 1904 by boating enthusiasts and still sits at the very southern end of Budd Inlet.

Olympia Harbor Days has become the signature event celebrating South Puget Sound's maritime heritage. The festival began in 1974 when the owners of several historic tugs, steamboats, and sailing ships brought their vessels to Olympia to show the public the South Sound's maritime past. The following year, a Labor Day weekend tradition began with tugboats races sponsored by the South Sound Maritime Heritage Association. The largest gathering of historic tugs and other vessels was in 1989 to celebrate the state of Washington's centennial. Continuing today, these tugboat races recreate the days when tugs raced out to incoming sailing ships to win the right to tow the large vessels into port. Since 1979, a popular arts and crafts event has been held in conjunction with the display of historic tugs on Saturday and races on Sunday.

One

Native Master Mariners
The Canoe Peoples of South Puget Sound

For many millennia, the first peoples relied on the rich resources of what is today called South Puget Sound for food, shelter, and to give meaning to life. The thick forests that surrounded South Puget Sound made overland travel very difficult. However, the sound's protected waters provided a convenient way for indigenous people to travel about, harvesting fish and shellfish and visiting neighboring villages dotted along the shoreline.

To travel the sound's waters, they used canoes carved out of huge cedar trees. The canoes ranged in size from those for one or two paddlers to ones that could carry 20 to 30 people or considerable cargo. It took a skilled canoe builder months to hollow out a cedar log and carve the outside into a graceful shape that slid easily through the water. Colorful designs were painted or carved on the sides and sweeping prows of the craft.

The indigenous people were master mariners whose skills and sturdy canoes allowed them to range up and down Puget Sound. They traveled with the seasons as the salmon runs arrived and berries and plants ripened. They built their permanent longhouses of sturdy cedar logs and roofed with cedar shingles. During summers, the native people would set up temporary camps along the shoreline at favorite spots to fish, hunt, and gather. Clams and mussels were always available when the tide was out. Occasionally, they would have to defend themselves from marauders who swept down from the northern Salish Sea, now part of Canada. However, today, Native Americans and the former marauders, now the First Nations of Canada, come together to celebrate their vibrant common canoe culture.

Traditionally, the first people would gather annually at a village for days of lavish celebrations, called potlaches, with songs, dances, and feasts. The white settlers, however, actively discouraged these potlaches, and the tradition died out. Washington State's centennial celebration in 1989 saw the first gathering in generations for tribes to again celebrate their common heritage. Dozens of tribes from around the regions set out from their homes to paddle to Seattle, often over long distances, to gather together once again. The success of the "Paddle to Seattle" encouraged Native Americans and Canadian First Nation people to make this gathering an annual event that is hosted in turn by the region's tribes, including the Nisqually and Squaxin tribes in South Puget Sound.

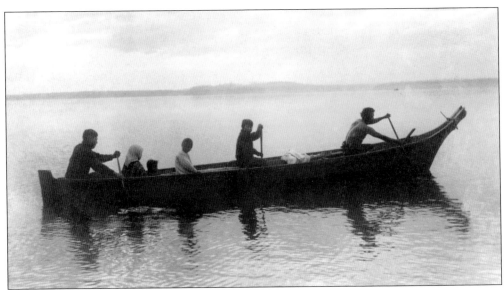

A family paddles its canoe just offshore. They are probably returning to their winter village from summer camp, where they would have gathered clams and oysters and a variety of berries they preserved for the winter months. This beautiful canoe with sweeping lines was, as was common, carved out of a single large cedar tree. (Courtesy of Museum of History & Industry.)

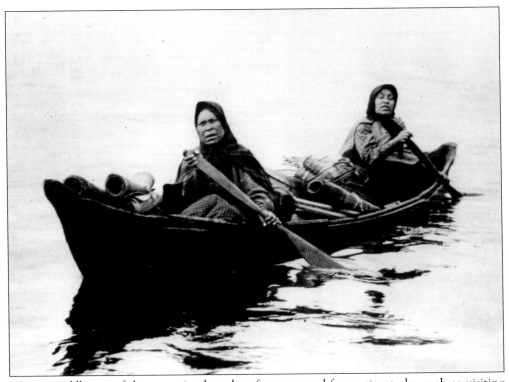

Women paddle one of the more simple styles of canoes used for routine tasks, such as visiting a neighboring village or going to a favorite berry field or to harvest other plants. (Courtesy of Kae Paterson.)

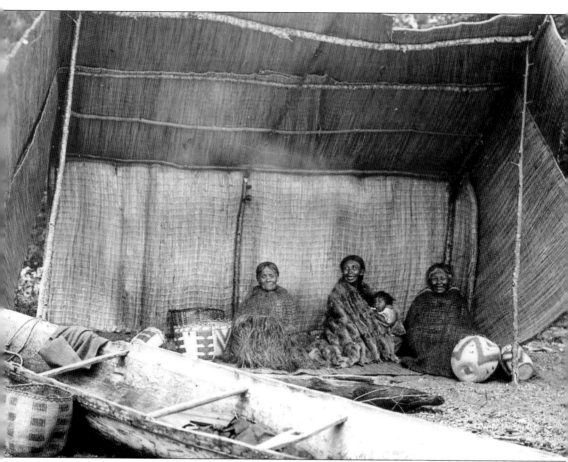

Two women, one with a baby, and an elder rest inside their summer shelter. These shelters were made of mats woven from cattail leaves or the inner bark of cedar trees. They could be easily transported from place to place. Scattered about are everyday baskets with intricate designs. The family canoe lies ready to take them to a clam or oyster bed or down the beach to a berry patch. (Courtesy of Tacoma Public Library.)

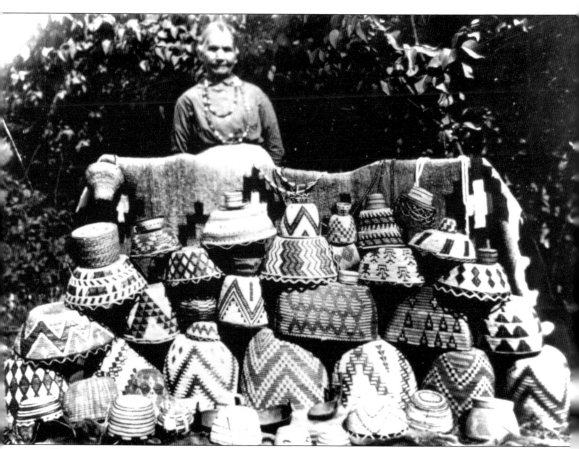

This array of typical Puget Sound native baskets represents several types made for different purposes. These baskets were typically made of the inner bark of cedar trees. A tightly woven basket would be made to carry water. A more flexible basket would be used for holding personal items. A general-purpose basket of rougher design would carry large or heavy items, including clams, oysters, and fish. (Courtesy of Washington State Archives.)

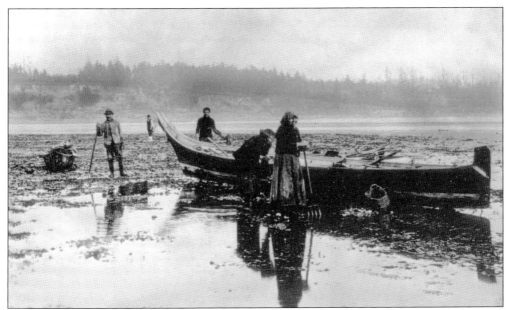

A family is seen here harvesting. It was a common saying that "when the tide is out the table is set." Note they have adopted the use of metal pitchforks to rake up the clams. (Courtesy of Washington State Archives.)

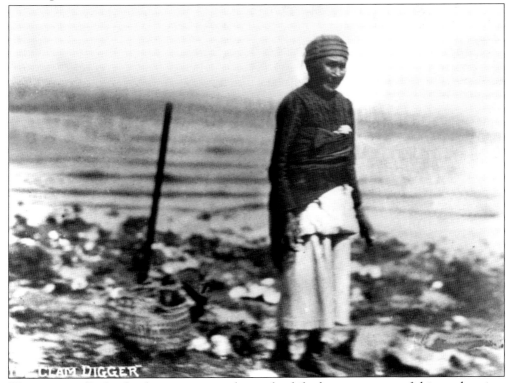

Women typically dug for clams, oysters, and mussels while the men were out fishing or hunting. The bivalves provided fresh food and also were smoked as a winter treat. (Courtesy of Washington State Archives.)

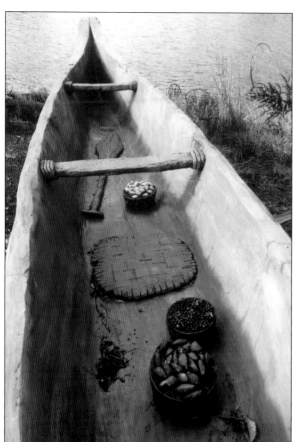

This replica canoe shows a typical summer harvest of clams, mussels, and berries. (Photograph by John Hough.)

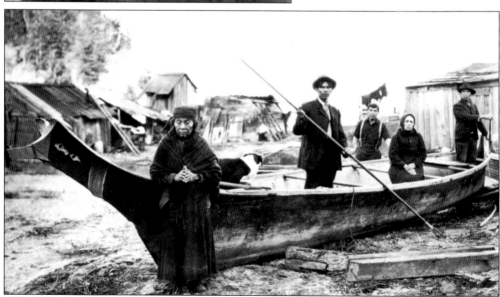

A family proudly poses with its canoe as the family dog looks on. Note the elaborate sweeping bow. The man in the center has a pronged pole used for spearing fish. (Courtesy of Washington State Archives.)

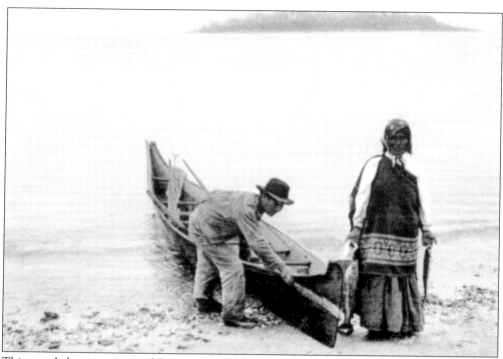

This couple has just returned from a successful fishing trip. They have adopted western dress as it was more convenient, but they still carry out the traditional right of harvesting fish. (Courtesy of Tacoma Public Library.)

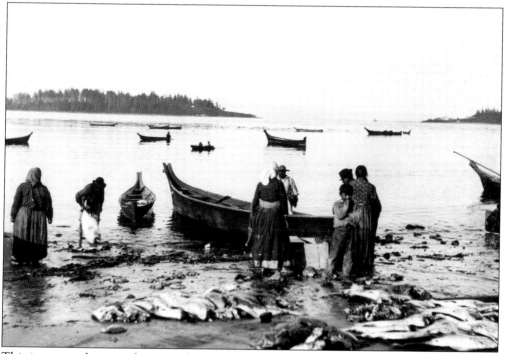

This is a typical scene when men have returned home with their catch from fishing in open waters. The entire village turns out to help. (Courtesy of Tacoma Public Library.)

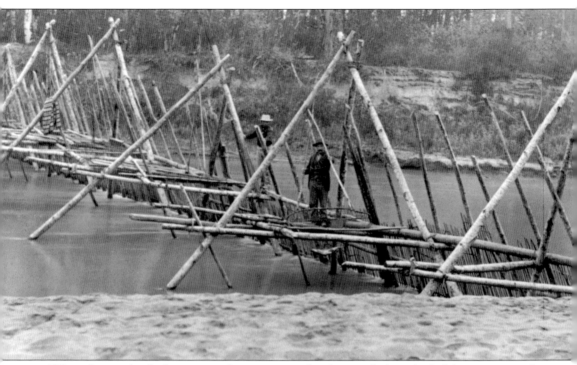

When thousands of salmon arrived to migrate up local rivers, Indians built fish traps across the river to snare the treasured fish. This was much more efficient than fishing on the open water. (Courtesy of Washington State Archives.)

The traditional way of cooking salmon is to fillet the fish and cook it over hot coals. (Courtesy of Washington State Archives.)

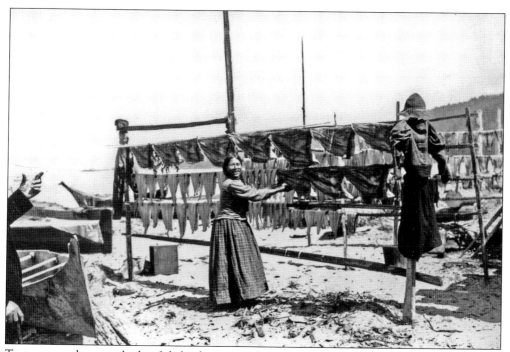

To preserve salmon and other fish for the winter, they were dried on racks. Here, a woman smiles at the camera as she tends the drying racks. Note the scarecrow on the near end of a rack. (Courtesy of Washington State Archives.)

When tribal members settled in for the cold, rainy winter, extended families would shelter in sturdy cedar longhouses similar to this one. (Courtesy of Washington State Archives.)

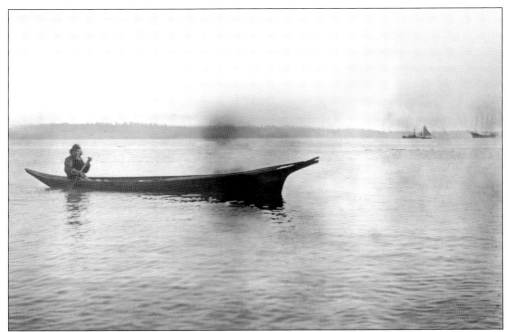

A man sits in his canoe with the classic sweeping bow. A canoe of this size could hold five or six people. These were seaworthy vessels, equally suited for the region's rivers or rough weather on Puget Sound. This 1900 photograph shows the changes taking place with a steamer and two sailing ships in the far background. (Courtesy of Museum of History & Industry.)

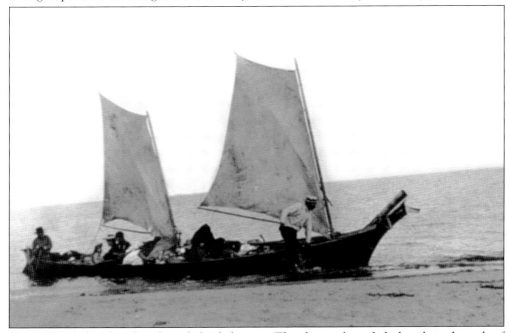

Here. a family beaches their heavily loaded canoe. They have adopted cloth sails in the style of the longboats early British explorers used to explore Puget Sound. However, Puget Sound Indians used sails made of woven cedar bark long before European contact. (Courtesy of University of Washington Library, Special Collections.)

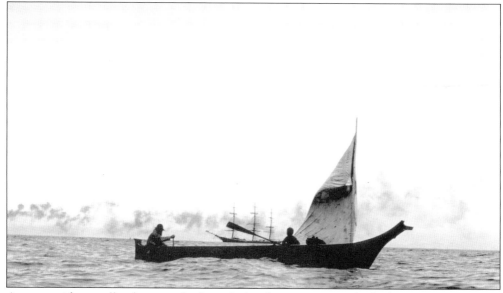

A canoe with a small sail cuts easily through the choppy water. In the background is the smoke stream from a tug pulling a three-masted ship bound up Puget Sound. (Courtesy of Museum of History & Industry.)

Well-dressed local townspeople visit an Indian camp. As Washington Territory flooded with people looking to farm or make their fortune, they found curious the indigenous people's traditional way of life. Indians still rely on the traditional cedar canoe, but convenient tents have replaced mat shelters as temporary homes. (Courtesy of Tacoma Public Library.)

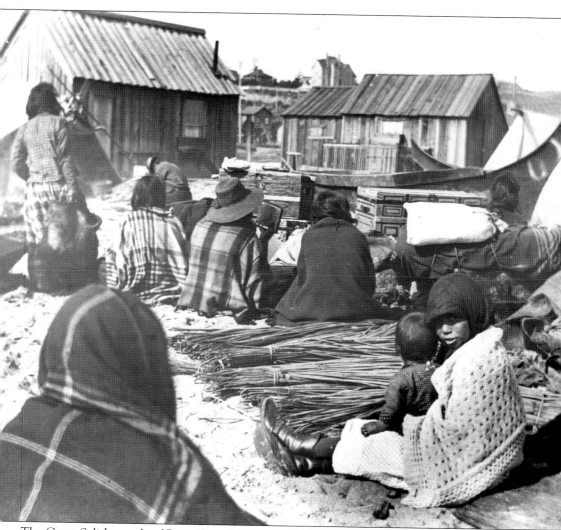

The Coast Salish people of Puget Sound maintained a long tradition of gathering annually for potlatches. Villages took turns hosting these festivities, at which guests would be provided gifts and an elaborate feast. There would be days of storytelling, singing, and dancing. Here, several women wait patiently for the potlatch festivities to begin at what was probably one of the last traditional ones. Note the woman near the center looking at herself in a mirror, a highly prized article. White settlers actively discouraged these gatherings, and they gradually died out. (Courtesy of Washington State Archives.)

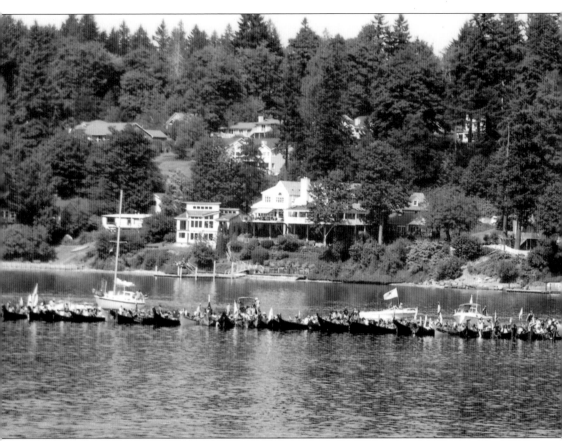

Canoes from scores of tribes line up waiting to come ashore for a modern potlatch celebration hosted by the Squaxin Island tribe. After the 1989 "Paddle to Seattle," the Puget Sound tribes revived the tradition of annual visits to each other's villages for celebration of the potlatch. Now tribes from throughout the region, Alaska, and British Columbia participate. The port has twice been the landing site for this event. Tribal members paddle their canoes to each year's site from throughout the region and now even come from other states and British Columbia, Canada. Both the Squaxin Island tribe and the Nisqually Indian tribe have hosted canoe journeys and potlatch celebrations. (Photograph by John Hough.)

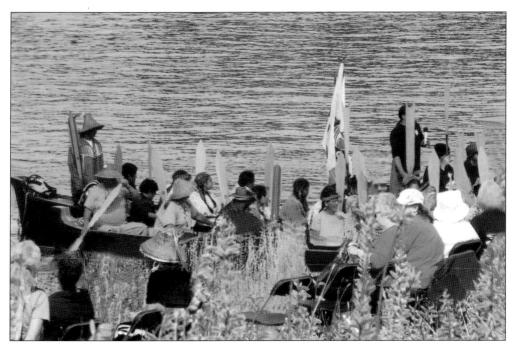

Two canoes have just landed at the Port of Olympia beach after the traditional request for permission to come ashore was granted. The paddlers are dressed in colorful native costumes with traditional conical cedar bark hats. Hundreds of people come to watch the landing and are invited to share in the potlatch celebrations. (Photograph by John Hough.)

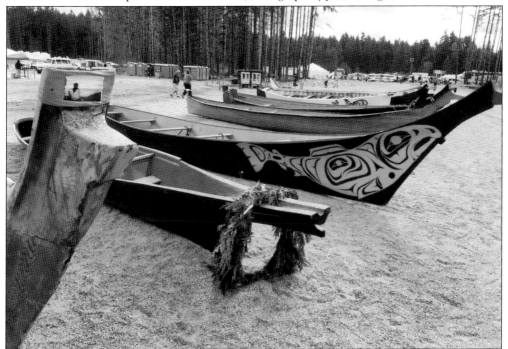

Canoes are lined up for viewing at a potlatch celebration. While contemporary, the canoes are made in the traditional fashion starting with a large cedar tree. (Courtesy of Patrick Eldridge.)

The entrance to a contemporary potlatch celebration shows both an honoring of tradition with classical canoe paddles welcoming guests and modern tents to protect everyone from the weather. The canoe culture developed thousands of years ago is once again a vital part of the region's heritage. (Courtesy of Patrick Eldridge.)

Two

EARLY ENCOUNTERS

EUROPEANS AND AMERICANS ARRIVE IN THE UPPER SOUND, 1792–1850

The first accomplished sailors in what is now known as South Puget Sound were the canoe paddlers of the indigenous Indians, the Salish tribes, and the fierce northern people from the 55th parallel north, the Haida, Gitskan, and Tlingit, who preyed upon the Salish for slaves. The first Europeans who encountered these splendid mariners were Capt. George Vancouver, Royal Navy (RN), and his expedition, including Peter Puget, Joseph Whidbey, and Archibald Menzies, in May 1792. His purpose was threefold: Settle with the Spanish over possession of Nootka Sound on New Albion (later Vancouver Island), chart the waters of the Northwest Coast, and reinvestigate the possibility of a Northwest Passage across North America. Captain Vancouver anchored near the future site of Seattle and sent his second lieutenant, Peter Puget; sailing master (navigator) Joseph Whidbey; and naturalist Archibald Menzies south in two ships' boats to chart the unknown inlet. Puget and his party determined that there was no passage crossing the continent from these waters. Their charts were so well drawn that Vancouver honored Puget by naming the southern inlet "Puget's Sound." Today, the entire inlet bears the name Puget Sound, and the branch explored by Puget is South Puget Sound.

In November 1824, a 48-man Hudson's Bay Company (HBC) brigade ventured north from Fort George (later Astoria) to the Fraser River near present-day Vancouver, British Columbia. The brigade crossed the Columbia River, paddled through Willipa Bay, and pulled their boats through the coastal surf to the Chehalis and Black Rivers and into Puget Sound at Eld Inlet. Chief factor (director) James McMillan commanded the brigade, and one of his clerks was John Work. Also aboard was the first American in these waters, William Cannon. A number of HBC posts, including Fort Nisqually at today's town of DuPont, were founded as a result of this trip.

The next major incursion into Puget's Sound was in 1841. The US Exploring Expedition was commanded by US Navy lieutenant Charles Wilkes, who placed 261 American names (ships, naval heroes, sea battles, crew members) on geographical features in the sound, including the Olympia area inlets Eld Inlet (Midshipman Henry Eld) and Budd Inlet (Lt. Thomas Budd), from his crew. Wilkes's charting and naming in the sound was a factor in the international border being drawn at the 49th parallel in the 1846 negotiations with Great Britain.

An extraordinary assembly of seagoing scientist adventurers accompanied these three early visits to South Puget Sound. George Vancouver's naturalist and physician Archibald Menzies, who visited in 1792, collected many plants and gave his name to the Latin designation of the Douglas fir, *Pseudotsuga menziesii*. David Douglas (who visited in 1825–1833), John Work (1824–1860), and Dr. William Tolmie (1833–1860) capitalized on their HBC affiliations to enhance the world of botany and zoology. The Wilkes Expedition included 11 scientists whose specimen collections from around the world from 1838 to 1842 caused the Smithsonian Institution to build its "Castle" to house many thousand items of science. Most spent time in South Puget Sound and lent their names to its geography; volcanologist James Dwight Dana, naturalist/artist Titian Peale, linguist Horatio Hale, botanist William Brackenridge, naturalist Charles Pickering and artist Joseph Drayton were just a few.

These hardy and venturesome men opened the door to South Sound settlement wide.

British captain George Vancouver, RN, successfully commanded the epic four-year expedition (1791–1794) that charted Puget Sound, the straits of Juan de Fuca and Georgia, the Inside Passage, and Vancouver Island. He and his crew were the first Europeans to visit South Puget Sound. His mission on this "Voyage of Discovery" was to recover from the Spanish the territory they had seized at Nootka; explore the coast as far as Alaska, searching for a Northwest Passage; and chart the Strait of Juan de Fuca and adjacent waters. He carried out his duties admirably. He also took a sun sight on May 27, 1792, at 47 degrees, three minutes north latitude, at the mouth of the Deschutes River, on what is now Budd Inlet and the Port of Olympia. Vancouver died in England while compiling his voyage journal in 1798. The journal was completed by his brother John and by Peter Puget.

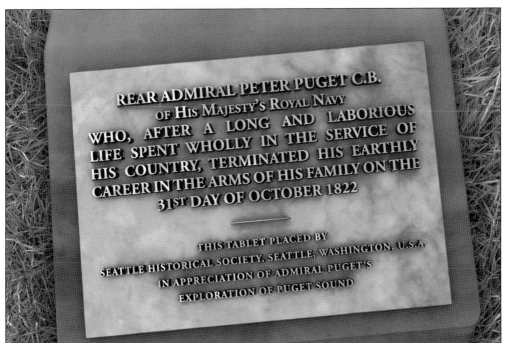

REAR ADMIRAL PETER PUGET C.B.
OF HIS MAJESTY'S ROYAL NAVY
WHO, AFTER A LONG AND LABORIOUS
LIFE SPENT WHOLLY IN THE SERVICE OF
HIS COUNTRY, TERMINATED HIS EARTHLY
CAREER IN THE ARMS OF HIS FAMILY ON THE
31ST DAY OF OCTOBER 1822

THIS TABLET PLACED BY
SEATTLE HISTORICAL SOCIETY, SEATTLE, WASHINGTON, U.S.A.
IN APPRECIATION OF ADMIRAL PUGET'S
EXPLORATION OF PUGET SOUND

Lt. (later rear admiral) Peter Puget, RN, served as a midshipman with George Vancouver in the Caribbean during the American Revolution, and Vancouver then selected him as his second lieutenant on the voyage to the Northwest Coast. On May 19, 1792, Puget took command of two ships' boats and left the HMS *Discovery* anchored off the future site of Seattle. Puget's seven-day trip charting the waterways to the south was so successful that Vancouver honored him by naming those waters "Puget's Sound." Puget later was a post captain, commissioner of the Navy in India, and died a Royal Navy rear admiral in 1821. No portrait exists, but this marker was erected by the Seattle Historical Society at his gravesite near Bath, England. He charted virtually every inlet and cove in South Puget Sound.

Sailing master Joseph Whidbey, RN, was the 35-year-old Vancouver expedition navigator. He was an expert and reliable officer, serving as Lieutenant Puget's second-in-command as they charted virtually the entire South Puget Sound from May 20 through 27, 1792. In June, Puget and Whidbey sailed through Deception Pass, circumnavigating the second-largest island in the continental United States, which Vancouver promptly named "Whidbey's Island." Whidbey returned to England and pursued a very successful Royal Navy engineering career. He designed breakwaters like Plymouth's, managed large dockyards, and was named a Fellow of the prestigious Royal Society, a singular honor for a Navy officer.

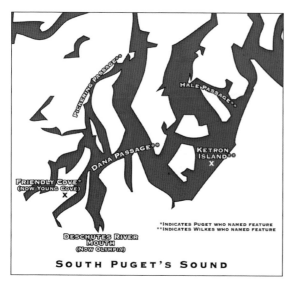

SOUTH PUGET'S SOUND

*INDICATES PUGET WHO NAMED FEATURE
**INDICATES WILKES WHO NAMED FEATURE

The South Sound has many inlets, bays, coves, and passages, making it a difficult charting job. Vancouver gave Whidbey and Puget five days for the work. When they did not return at the deadline, Vancouver, an impatient man, set out with then third lieutenant Joseph Baker in the longboat and gig to find Puget and Whidbey. Puget headed back to the HMS *Discovery* near present-day Seattle on May 26, and the two parties saw each other at dusk, mistaking one another for Indians. Vancouver marked the present site of Olympia the next day at 47 degrees, three minutes north latitude, and also headed north. So impressed was he with Puget's charts that he named the South Sound Puget's Sound.

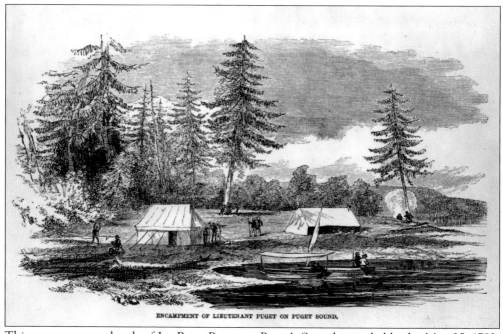

ENCAMPMENT OF LIEUTENANT PUGET ON PUGET SOUND.

This encampment sketch of Lt. Peter Puget on Puget's Sound is probably the May 25, 1792, encampment of Puget, Whidbey, and Menzies on the north end of Griffin Peninsula, near Steamboat Island. Their journal described their location on the south shore of Squaxin Passage as in "a very pleasant situation." They looked west toward sunset with the Mason County hills in the distance. (Courtesy of Washington State Archives.)

Pictured here is one of two coves that sat across the inlet from one another and where Puget landed May 26, 1792, to encounter Indian villages, probably Squaxin. Puget named this cove, on the west side, Friendly Cove from the nature of the amicable reception he received from its residents. (Photograph by John Hough.)

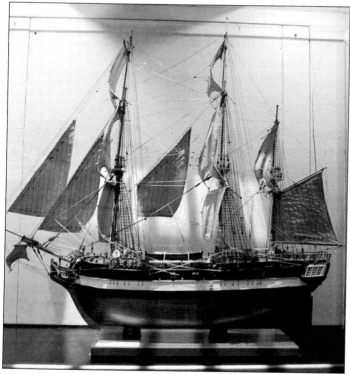

Vancouver's flagship, the HMS *Discovery*, a survey sloop of war, was 337 tons and 96 feet long. She carried 135 men, stores for a five-year voyage, and 10 four-pounder cannon in her broadside. Owing to a recent mutiny aboard the HMS *Bounty*, she carried a larger Marine detachment than usual and her consort, the HMS *Chatham*, a brig that normally would have no Marines, carried a contingent of 10 Royal Marines. Her four ship's boats—cutter, launch, longboat, and gig—under the commands of Puget, Vancouver, 2nd Lt. Joseph Baker, and sailing master Joseph Whidbey, charted almost the entire South Puget Sound.

Botanist, surgeon, and physician Archibald Menzies sailed with Vancouver as a supernumerary, a privileged passenger, to collect botanical specimens from the unexplored Pacific Northwest, with the encouragement of Sir Joseph Banks, president of the Royal Society. Vancouver's surgeon died en route, and Menzies volunteered to replace him. In his time ashore in Oregon Country, he collected hundreds of specimens. He later mentored David Douglas. The Latin name for the Douglas fir honors Menzies: *Pseudotsuga menziesii*. He was named a Fellow of the prestigious Linnaeus Society. He accompanied Puget and Whidbey from May 20 to May 27, 1792, in South Puget Sound, collecting and cataloging numerous plant specimens.

As a midshipman, Joseph Baker had been mentored by Capt. (later admiral) James Vashon, also one of Vancouver's patrons. Vancouver named Vashon Island in central Puget Sound in his honor. Vancouver selected Baker as his third lieutenant as the voyage began. Baker became quite accomplished at cartography and is responsible for turning Puget's work into usable charts. He accompanied Vancouver on his South Sound journey to present-day Olympia in May 1792. After First Lieutenant Mudge left with dispatches for England that August, Baker was promoted to second lieutenant. He later rose to captain's rank and maintained his close relationship with Admiral Vashon until the latter's death in 1808. Mount Baker in the north Cascades is named for him. (Courtesy of Graybeard Publishing.)

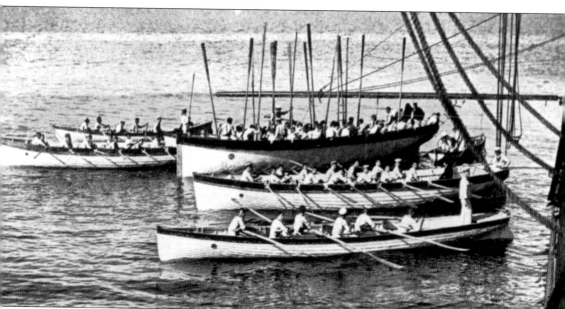

The boats used by Puget and Vancouver for the South Sound exploration were the cutter, launch longboat, and gig. They differed in size and qualities under sail or oars. This ship's boat photograph shows the visual differences among gigs (closest), cutters (middle), and launches (distance). Gigs were shorter, narrower, and light, designed for both sail and oar. Cutters were also shorter than the larger boats, broader, deeper, and better sailed. Launches were lower freeboard, longer, and good for rowing. The longboat (not pictured) was more "ship-like" and sailed well. This photograph was taken a century after the Vancouver visit, yet the relative boat proportions and qualities remained the same, according to W.E. May's *The Boats of Men-of-War*, originally published by the British National Maritime Museum.

First Lt. of the HMS *Discovery* was apparently not well thought of by Vancouver, who dispatched him back to England at the first opportunity, in August 1792. Any tension between them may have stemmed from Mudge's close connection to the powerful Pitt family. The Honorable Thomas Pitt, later the 2nd Baron Camelford, was aboard as a midshipman, and this spoiled and arrogant 16-year-old was a thorn in Vancouver's side. Mudge's later career saw him promoted to captain in 1800 through the influence of the Camelfords, followed by many successful commands and captures until 1815, when he went to the inactive list. Nonetheless, he rose thereafter to flag officer, was named an admiral in 1849, and died a distinguished naval officer in 1852. Had he been better regarded by Vancouver, the area might have been known as Mudge Sound.

The Honorable Thomas Pitt, 2nd Baron Camelford, was a midshipman who believed himself far superior to Vancouver, a commoner, and rejected the normal punishments of a seagoing life as cruel and unjust. Vancouver had little choice in accepting Pitt, as Pitt's brother-in-law was Lord Grenville, the foreign secretary. Pitt was jealous of Midshipman Manby, who went with Puget and Whidbey to South Sound. Vancouver finally assigned him to the HMS *Daedalus,* the expedition supply ship, bound for England. When Vancouver ultimately returned to England, Pitt challenged him to a duel, caned him in the street, and assaulted his brother. Pitt's life was marked by dueling, failed commands, murder, conspiracy, a quixotic plan to assassinate Napoleon, and his death in a duel with a friend in 1804. He was often referred to as "the half-mad lord."

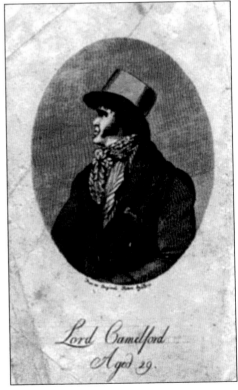

Lord Camelford Aged 29.

Vancouver had served under Peter Rainier, then a captain in command of the Jamaica Station. Rainier took an interest in Vancouver's career. Rainier was made rear admiral in 1795, commanded the East Indies Station, and retired a vice admiral in 1805. Junior exploring officers often named geographic features for their patrons, and Vancouver named the highest peak in the Cascades for Rainier.

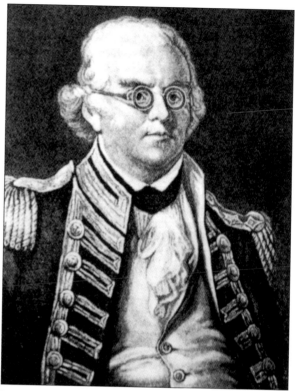

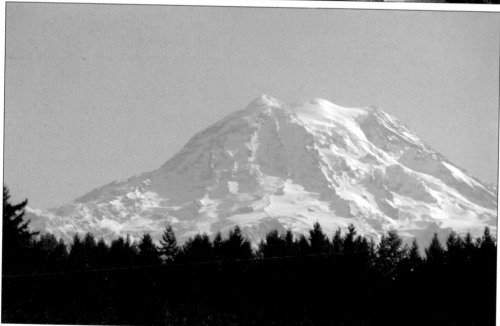

Washington State's Cascade Range was named Mount Rainier by Vancouver for his patron, Peter Rainier, RN. In 1841, Charles Wilkes of the US Navy measured it, and Dr. William Tolmie of the Hudson's Bay Company's Fort Nisqually was among the first to climb it. (Photograph by John Hough.)

Born in County Donegal, John Work came to the HBC and was a clerk for McMillan's 1824 November and December expedition from Fort George to the Fraser River, exploring a new route north. His journal described "proceeding under a weighty rain." The successful expedition began Work's rise in the HBC ranks. He was later chief factor of HBC posts in Colville, Spokane, and on the British Columbia coast. He ultimately became the largest landholder on Vancouver Island. He was an accomplished self-taught naturalist and frequently aided David Douglas. His daughter Jane married Dr. William Tolmie, chief factor at Fort Nisqually. He thus was among the first Europeans to visit South Puget Sound, from the Black River and McLane Creek through Eld Inlet, Dana Passage, and Nisqually Reach to the Tacoma Narrows.

Sir George Simpson was a governor of the HBC for four decades. He was described by Peter C. Newman, HBC historian, as a "buccaneering capitalist." Tough, driven, unafraid, and relentless were other descriptors. He usually made his entry into a post or event to the skirl of bagpipes. This dramatic and energetic man sent chief factor McMillan of Fort George north through South Puget Sound to assess an alternate route when the Cowlitz tribe closed the river and land trail from the Columbia River to Puget Sound in 1824. McMillan rejected the new route as impractical, but the HBC established Fort Langley on the Fraser River soon after. This was the first expedition to South Puget Sound since Vancouver, and Simpson's determination established Fort Nisqually as a major trading post.

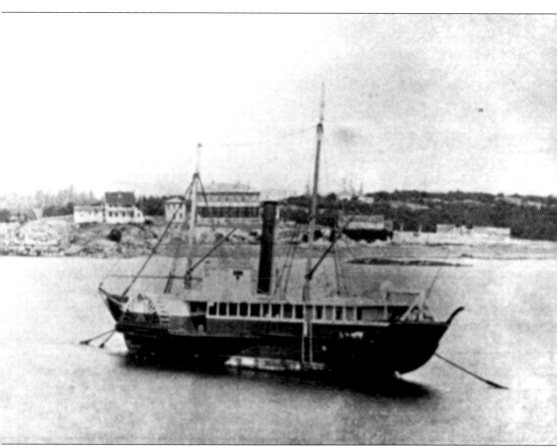

In August 1835, the HBC steamer *Beaver* left London for Fort George (later Astoria) and the mouth of the Columbia River, arriving in March 1836, the first steamboat in the Pacific. HBC governor George Simpson had lobbied for the ship to be built, citing the advantage she would give HBC over Americans in the fur trade among the inlets and coves of the Northwest Coast. The 187-ton side-wheel paddle steamer carried 31 men, including 12 "axe men" to cut the many cords of wood she would burn in one day. She was also rigged for sail, served as a trading and passenger ship, and was briefly chartered by the Royal Navy. After her last 18 years as a private towboat, she was wrecked in Vancouver, British Columbia, in 1888. She was a frequent visitor to Fort Nisqually and South Puget Sound, first with the HBC and later as a privately owned tugboat towing log rafts to Olympia. (Courtesy of Washington State Archives.)

Maria Mahoi Kamahehe is typical of the many Hawaiians (Kanaka) brought here to work for the HBC. Hawaiians were prized as the finest sailors in the Pacific. Fifteen thousand Kanaka sailors worked annually in the Bering Sea whaling fleet. Their strong work ethic made them valuable HBC employees. Kamahehe's father, Bill, was a sailor aboard the steamer *Beaver* and made many trips to Fort Nisqually from 1837 to 1848. (Courtesy of Tom Koppel.)

David Douglas, a Scottish plant collector and naturalist mentored by Menzies, was 26 when he journeyed for the London Horticultural Society and the Linnaeus Society on an HBC ship to Fort George in 1825. After trips to The Dalles and the Willamette River, he ventured north in October with Chinook chief Concomly's brother Tha-mux-I, to Grays Harbor and up the Chehalis River past the confluence with the Black River through the southern confines of Thurston County and South Puget Sound. There he noted the correct pronunciation of the salal plant, munched on wapato and seashore lupine, and fished the salmon runs. His ventures led to travel between Puget Sound and London, crossing North America by canoe and horseback, returning to the Northwest again, discovering many more plants, and dying a tragic death in Hawaii in 1834.

This young University of Glasgow medical student, John Scouler, was also a devoted naturalist and friend of David Douglas. The two botanical collectors sailed aboard the HBC ship *William and Ann* in 1824 for the Pacific, collecting all the way on the eight-month voyage to Fort George. Scouler served as the ship's surgeon and was an early visitor to South Puget Sound. They spent time together collecting on the Columbia River, and Scouler then found his way through the Puget Sound country to Nootka on Vancouver Island. He returned to Great Britain in 1826; graduated and practiced medicine until he became a university professor of geology, botany, and zoology; wrote scores of books; and was made a Fellow of the Linnaeus Society. He was recognized as a prominent naturalist. Scouler died in 1871.

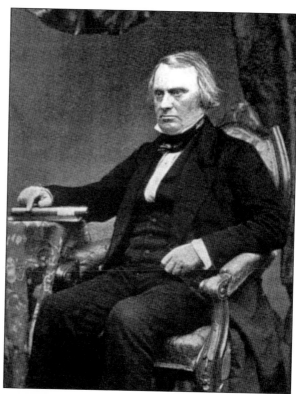

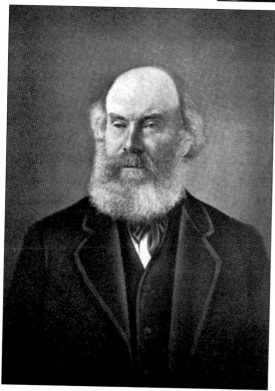

In 1833, William Tolmie, a recent graduate in medicine from Glasgow University, arrived at Fort Vancouver and soon travelled north to Fort Nisqually, collecting flora and fauna specimens as he went. He was puzzled by the Mima mounded prairies in Thurston County and wondered at Mount Rainier, which he would later climb. He traveled by land and water throughout the Northwest, practicing medicine among the HBC people and the Indians and collecting constantly. Ten years later, he was chief factor at Fort Nisqually, where he stayed well into the 1850s, when he defended the cause of Chief Leschi of the Nisqually as he was judicially murdered by the territorial government.

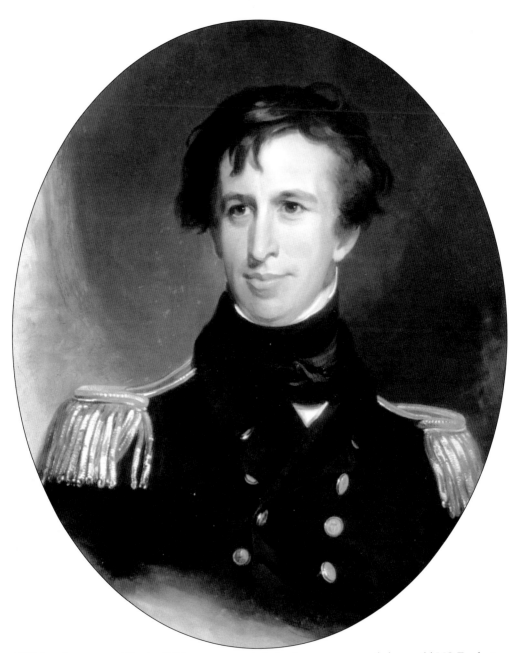

US Navy lieutenant Charles Wilkes commanded the four-year, around-the-world US Exploring Expedition from 1838 to 1842. He discovered Antarctica and charted the Pacific and its wind and current patterns. Six months of the voyage was spent in Puget Sound, which was then under a joint occupation treaty between Great Britain and the United States, where he charted and named 261 geographic features for US Navy heroes, ships, and his crew, helping to ensure that Washington became US territory when the border was set in 1846. Half of those names were placed in South Puget Sound. His survey crews charted Hammersly Inlet, one that Puget had failed to find.

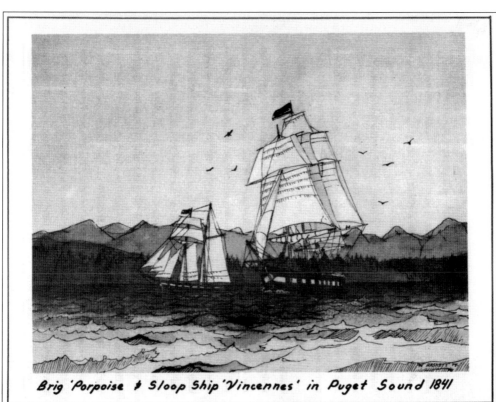

Brig 'Porpoise' & Sloop Ship 'Vincennes' in Puget Sound 1841

Pictured here are the brig *Porpoise* and ship sloop *Vincennes* in Puget Sound in 1841. The artist, the late Patrick Haskett, was a veteran tugboat skipper from Olympia, Washington, whose paintings have hung in the Peabody Museum and command the attention of hundreds of maritime art collectors. This reproduction of a watercolor from his very early years was an illustration in his book on the Wilkes Expedition in Puget Sound for his senior thesis at the Evergreen State College, published in 1974 by the Washington State Capital Museum. (Courtesy of Deborah Haskett.)

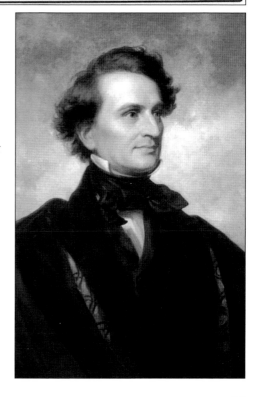

James Dwight Dana was one of the dozen scientists aboard the US Exploring Expedition. He was a geologist and volcanologist. He noticed that the easternmost island in the Hawaiian chain was volcanically active while the westerly ones were dormant, thus anticipating the hypothesis of tectonic plate movement, one of the great concepts of geology. The passage just north of Budd Inlet in South Puget Sound bears his name. He was a giant in his field.

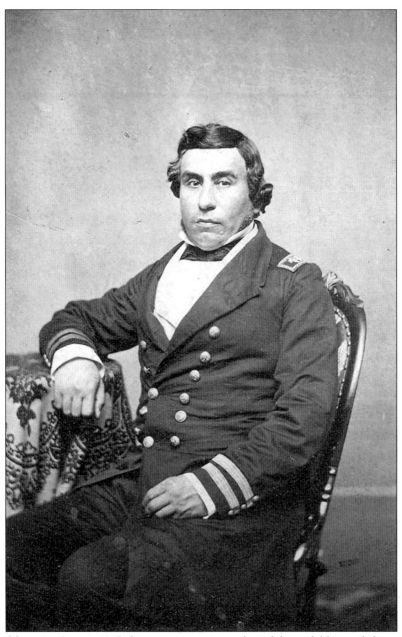

Passed Midshipman George M. Colvocoresses was a steady and dependable watch-keeping officer on the Wilkes Expedition. Wilkes named Colvos Passage and Colvos Rocks in Puget Sound for Colvocoresses. Wilkes, a notoriously bad speller, simply gave up and ignored the last three syllable of the Colvocoresses name. Of Greek descent, Colvocoresses later rose to the rank of captain and commanded the sloop USS *Saratoga* in the American Civil War. His son George P. Colvocoresses served aboard Dewey's flagship and the cruiser USS *Olympia* and later attained the rank of admiral. George M.'s adventure in South Puget Sound took him, with Midshipman Eld, up Eld Inlet to Black Lake, the Black River, the Chehalis River, and on to Grays Harbor. A passed midshipman had passed the US Navy lieutenant's exam and had the same duties as a lieutenant but had to wait for promotion owing to an overabundance of lieutenants.

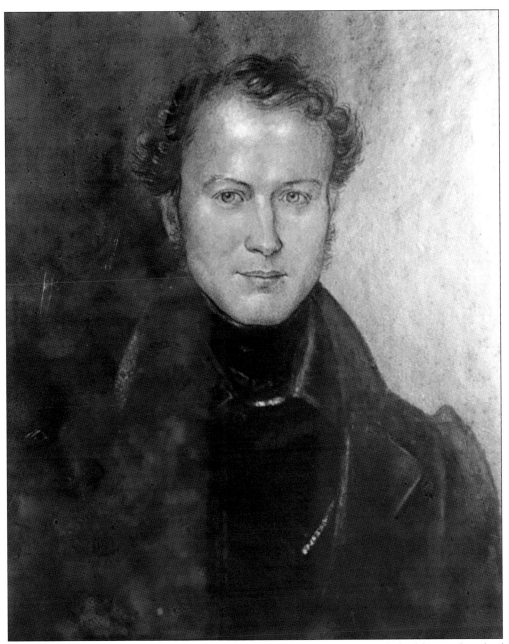

One of the expedition scientists, William Brackenridge, was an accomplished horticulturalist/botanist from the Edinburgh Botanical Gardens. Wilkes referred to his corps of naturalist as the "Scientifics." Brackenridge was on the overland trek to the Colville area in eastern Washington and then accompanied Eld through South Puget Sound and overland to Grays Harbor. Some of his colleagues referred to him as the "Prodigious Pedestrian."

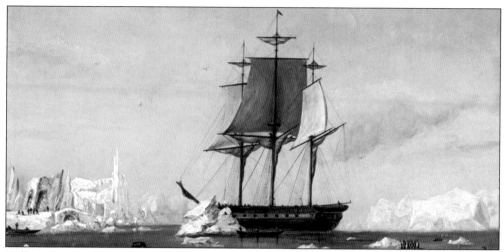

Wilkes's flagship sloop of war in his seven-ship squadron, the *Vincennes*, spent six months in Puget Sound, most of it in South Sound waters. This watercolor is attributed to Wilkes himself, when he charted Antarctica. naval officers were expected to draw and paint geographic features in the days before cameras. As the *Vincennes* entered Admiralty Inlet, she took aboard a Hudson's Bay Company (HBC) pilot who guided Wilkes to his primary South Puget Sound anchorage off Sequalitchew Creek near Fort Nisqually, the South Sound HBC trading post. This site is now in the city of Dupont.

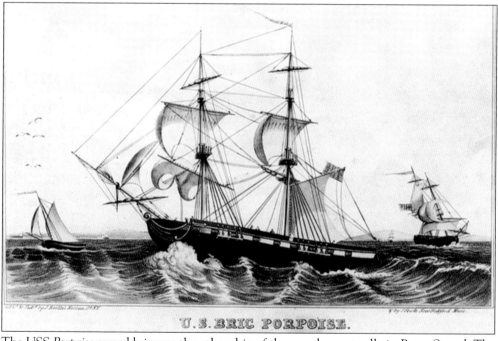

U.S. BRIG PORPOISE.

The USS *Porpoise* armed brig was the other ship of the squadron actually in Puget Sound. The schooner USS *Flying Fish* made it to the Columbia River and USS *Peacock,* a sloop of war, was wrecked on the Columbia bar. The ship *Oregon* was then purchased to replace the *Peacock. Seagull* had been lost off Cape Horn, and *Relief* was sent home from Callao. *Porpoise*, like the *Vincennes*, used the anchorage off Sequalitchew Creek in South Puget Sound often. Many of *Porpoise*'s crew explored and charted South Puget Sound.

A linguist, philologist, and naturalist from Harvard University, Horatio Hale was aboard the *Peacock* when she went down on the Columbia bar. He was granted leave by Wilkes to stay in South Puget Sound after the expedition left for New York, to carry out his studies of the tribal dialects and customs of the Nisqually, Squaxin, Chehalis, Cowlitz, and Skokomish, among others. Hale Passage, which separates Fox Island from Wollochet Bay in South Puget Sound, bears his name.

South Sound's Eld Inlet is named for Henry Eld. A passed midshipman with the US Exploring Expedition, Eld traversed Thurston and Lewis Counties on his way from Fort Nisqually to Grays Harbor, commanding a party that included botanist William Brackenridge and Passed Midshipman George Colvocoresses. He was later engaged to Wilkes's daughter, aided Wilkes in compiling his 15-volume journal, and died in the mid-1850s.

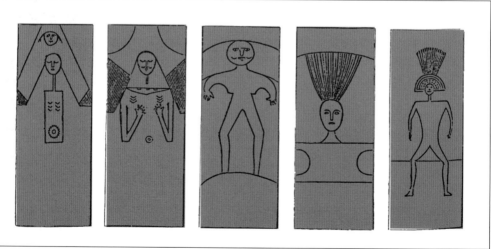

In their trek up Eld Inlet and McLane Creek through Black Lake to the Black River, Eld, Brackenridge, Colvocoresses, and their party encountered these carved planks erected near the confluence of the Black and the Chehalis Rivers. They attributed these mysterious figures to the Holloweena Band, a part of the Upper Chehalis Indian peoples. (Artist's rendering by Patrick Eldridge.)

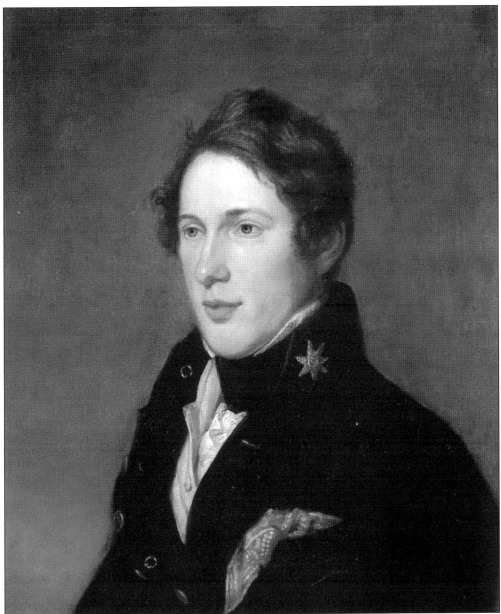

When Titian Peale came aboard as one of the expedition naturalists, he was already a famous and respected ornithologist, having collected for some of the day's great scientists in the Rocky Mountains, Florida, and South America. He spent most of the expedition's four years aboard *Peacock*, commanded by Captain Hudson, with whom he had a cordial relationship. When the *Peacock* was wrecked on the Columbia River bar, Peale was assigned to the *Vincennes* and struggled with the imperious Wilkes, as did almost every scientist and officer who encountered him. Wilkes's spiteful dislike of Peale led him to criticize, alter, and suppress Peale's excellent publication report on the thousands of birds encountered during the expedition. Peale was the son of Charles Willson Peale, founder of the prestigious Peale Museum of Philadelphia.

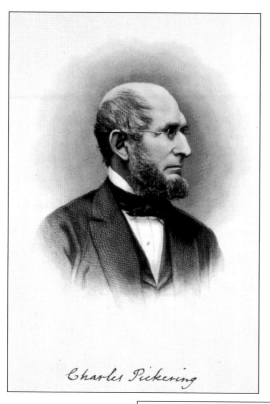

Charles Pickering

Naturalist Charles Pickering from the Academy of Natural Sciences, Philadelphia, was accomplished in ethnology, ichthyology, anthropology, herpetology, and botany. At sea, he found himself surrounded by stuffed geckos and lizards and by native peoples' baskets obtained in his many stops during the four-year circumnavigation. He was aboard *Vincennes* during her six months in South Puget Sound. Wilkes named Mason County's Pickering Passage in South Sound for him.

Geological mystery mounds in Thurston County, the Mima mounds, evoked comment from Wilkes and later puzzlement from Dr. William Tolmie, a chief factor of the Hudson's Bay Company in the Northwest. Controversy still rages over the origin of the gravelly mounds, preserved in two reserves by the State of Washington and by Thurston County. Were they created by giant gophers, or are they glacial formations? Scientists still differ on which one it might be. (Photograph by John Hough.)

This stone marks the location of the 1841 Wilkes Expedition observatory near Fort Nisqually. The observatory's primary function was the operation of a tripod-mounted pendulum measuring the thickness of the Earth's crust by differing rates of swing. Pierre Bouguer invented the process. Wilkes placed a similar observatory atop Mauna Loa. Its walls are still there. (Photograph by Pat Eldridge.)

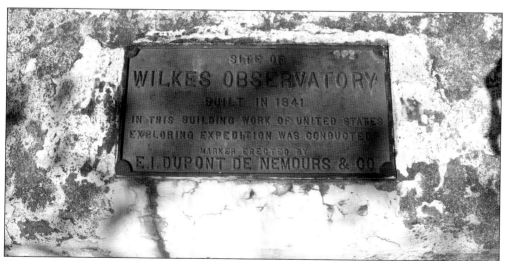

The stone and this plaque can be reached after a mile-long stroll along the bluff overlooking Ketron Island near the Chambers Bay Golf Course in Pierce County, Washington. Ketron Island was named by Wilkes for HBC Fort Nisqually employee William Kittson. Again, spelling was not a Wilkes strong point. (Photograph by John Hough.)

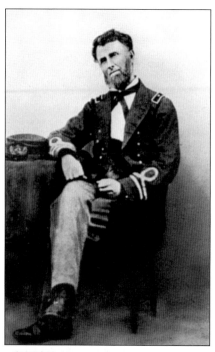

William L. Maury was a lieutenant, astronomer, and hydrographer on the Wilkes Expedition and a cousin of the famed marine scientist, Matthew Fontaine Maury. Wilkes named Maury Island, which is attached to Vashon Island by a narrow spit in South Puget Sound, for Maury. One of Wilkes's goals was to place many American names in Puget Sound so as to influence making the area American when border placement negotiations occurred. The settlement took place in 1846, and the border was drawn at the 49th parallel. Puget Sound became US territory. Both the Maury cousins cast their lot with the Confederacy during the American Civil War.

William Maury and Charles Wilkes later found themselves in opposing navies during the Civil War. Maury commanded this vessel, the raider CSS *Rappahannock*, a screw steamer also schooner-rigged, originally a Royal Navy corvette. She was sneaked out of Great Britain in violation of British neutrality law and detained in Calais by the French in 1864 and never fought for the Confederacy.

Three

STEAMERS AND SETTLEMENT
STEAMSHIPS, MARITIME COMMERCE, AND SETTLEMENT, 1851–1922

In 1853, Washington became a territory, and its first governor, Isaac Stevens, was appointed. Stevens was a West Point graduate, an officer in the elite US Coast Survey, and a future Civil War general. He was an ambitious, driven man, and these attributes helped bring turmoil, warfare, and a measure of injustice to the new territory. The local Indians, known as the Salish, were a collection of many varying bands, villages, tribes, and cultures. They in turn were often preyed upon by fierce northern tribes like the Haida, Tlingit, and Tsimshian, who raided the Salish for slaves. Yet the northern tribes would often come to Washington peacefully in the summer to work for the Hudson's Bay Company. The HBC Fort Nisqually, near the mouth of the Nisqually River, was a key outpost. The HBC had been a calming instrument between strident settlers and the Indians, as it general treated the indigenous people fairly.

Stevens forced the Indians to sign treaties they only marginally understood; some tribes did not sign. Stevens then placed them on reservations unsuited to their livelihoods, whether they had signed the treaties or not. The result was armed uprisings, and the US Navy responded overwhelming to these uprisings. As the fighting ended, a dispute over ownership of the San Juan Islands almost led to a shooting war between the British and the United States. It was narrowly averted by negotiations among members of the British and US armed services. Troops from Fort Steilacoom, near the future South Sound city, played a key role in the dispute. Many of the Americans involved soon were fighting against one another in America's Civil War.

A transportation system evolved in Puget Sound, beginning in the 1850s and not ending until the advent of the automobile and decent roads in the 1920s. Hundreds of steamships moved goods and people to villages and cities along the sound, churning and buzzing their way to serve the growing population, hence their title, the Mosquito Fleet. Colorful and competitive captains raced at every opportunity, striving for reputations as the fastest and most dependable boats along the water highway. Olympia was the southern terminus of the web of steamship routes that extended to every corner of the inland sea. Propelled by stern-wheel and side-wheel paddles and by screw propellers, their bellowing steam whistles shattered the silence of the often placid sound waters, and their presence engendered the construction of docks, shipyards, and navigation-dependent businesses. They engaged in "rate wars," undercutting each other's prices to gain a bigger share of the passenger market. They were the splendid vehicles on the superhighway that was the Puget Sound, and they live vividly in the memories of people in Washington.

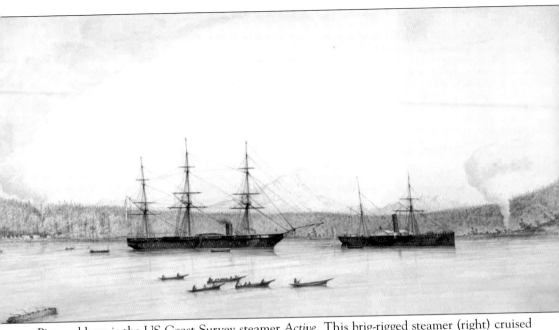

Pictured here is the US Coast Survey steamer *Active*. This brig-rigged steamer (right) cruised the waters of Puget Sound, the Strait of Juan de Fuca, and the San Juan Islands for two decades, her soundings helping to strengthen the US claim to Haro Strait as the border between British Canada and the United States. (The ship at left is the HMS *Satellite*). Her commander, James Alden (first here with Wilkes), frequently visited Olympia and Fort Steilacoom in South Puget Sound during his involvement in the Indian Wars of 1855 and the Pig War, which lasted from 1859 to 1872. The US Coast Survey is the antecedent of the National Oceanographic and Atmospheric Agency (NOAA). It was a prestigious assignment for a 19th-century Navy or Army officer. Isaac Stevens, Washington's first territorial governor, was a US Coast Survey officer and later a Union army general in the Civil War.

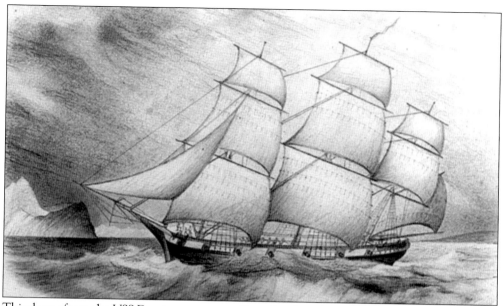

This sloop of war, the *USS Decatur*, was powered by sail only and at a disadvantage in the uncertain winds of the South Puget Sound. She was sent north from San Francisco in July 1855 because of rumored Indian discontent. Several more useful US steamers soon joined her, including *Active*. *Decatur's* commander, Capt. Isaac Sterrett, built a Seattle blockhouse for city protection in October as the Indians armed themselves for battle. Sterrett sailed to Fort Steilacoom to consult with the Army in November. *Decatur* was damaged in a raging December storm and beached in Seattle. In late January 1856, the *Decatur* was refloated, and her sailors successfully defended Seattle against the Indian attack on January 26.

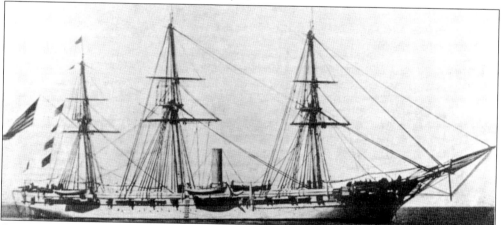

Capt. James Alden's first South Sound visits were as a lieutenant aboard the USS *Vincennes* off HBC's Fort Nisqually in 1841, followed by his conferences with Fort Steilacoom US Army commanders during the Indian Wars and the Pig War of the 1850s. On loan to the US Coast Survey, Alden made a secret visit to Gov. James Douglas on Vancouver Island in 1859 to plead for British patience in the Pig War controversy. He was successful, and no shots were fired. Alden is best known for evoking Admiral Farragut's famous declaration, "Damn the torpedoes, full steam ahead," at the 1864 Battle of Mobile Bay. Alden commanded the USS *Brooklyn*, the ship ahead of Farragut's USS *Hartford*, *Brooklyn*'s sister ship (pictured here), and had stopped to signal Farragut that "torpedoes" (floating mines) were ahead of the squadron.

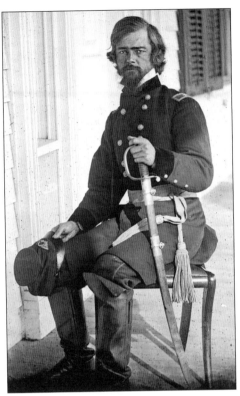

The first Washington Territory governor, Isaac Stevens, was an energetic, ambitious, and driven man. Stevens was a West Point graduate and a US Coast Survey officer before being named governor in the 1850s. Many scholars contend that he manipulated the region's Indian tribes into signing treaties they did not understand, giving up their traditional lands for inadequate Indian reservations. He clearly caused the unjust hanging of Nisqually leader Leschi for murder, when even the US Army declared that Leschi was a wartime combatant when he killed a settler and was not guilty of murder. Stevens died at the Civil War's Battle of Chantilly as a US brigadier general in 1862. He was headquartered in Olympia during his Washington Territory sojourn, frequently conferring with US Navy officers in the region.

George Edward Pickett was last in his class at West Point, decorated for valor in the Mexican War of 1848, and was a US Army captain on San Juan Island when the Pig War dispute with the British over possession of the San Juan Islands arose in 1859. He fortified the island with his company of infantry and guns from the USS Massachusetts. The British responded with warships anchored in Griffin Bay, their guns trained on Pickett's forces. A shooting war was narrowly averted by negotiation. His infantry regiment was headquartered at Fort Steilacoom, and he frequently sailed there aboard US Navy vessels. In 1861, Pickett resigned from the US Army to join the Confederate army, where he later led Pickett's Charge at Gettysburg as a Confederate major general. He left his son Jimmie (by his Haida wife, who died in childbirth) in the care of a friend living in Thurston County and then Mason County.

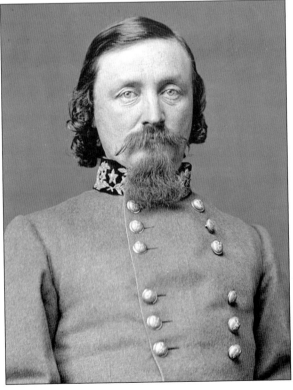

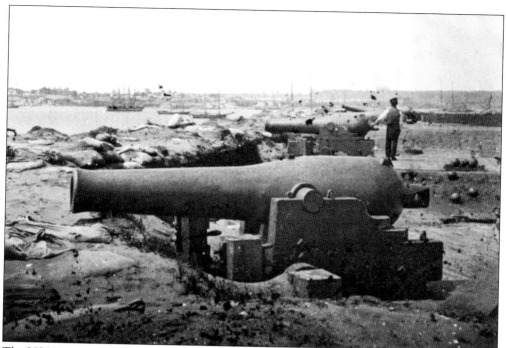

The US Navy steamer *Massachusetts* was a converted merchantman. She was actively involved in the 1855–1856 Indian War and the 1859 Pig War. She visited Olympia during those conflicts. The cannon pictured here was one of eight she sent ashore to US Army captain George Pickett to arm the redoubt at American Camp against the British in 1859. (Courtesy of Mike Vouri.)

Pickett had originally placed his infantry company at South Beach, an untenable location, and had been ordered to move it to the heights above Griffin Bay by his army commander, Col. Silas Casey. Pickett was, after all, last in his class at West Point. The guns from the USS *Massachusetts* were placed on the heights now known as American Camp in a redoubt, or fortification, designed by Army lieutenant Henry Martyn Robert. The guns were trained on the British warships in Griffin Bay as tensions rose over American presence on the disputed island.

Henry Martyn Robert was a young engineer lieutenant stationed at Fort Steilacoom with the 9th Infantry on South Puget Sound. He later served in the American Civil War and rose to brigadier general in the US Army Corps of Engineers. He is most well known for his authorship of *Robert's Rules of Order*, the definitive guide to meeting conduct in the United States. Tradition has that he was inspired to write *Robert's Rules of Order* by his attendance at a disorderly church meeting on the East Coast, but some believe his first inspiration may have stemmed from a similarly dysfunctional church meeting earlier in his life on South Puget Sound.

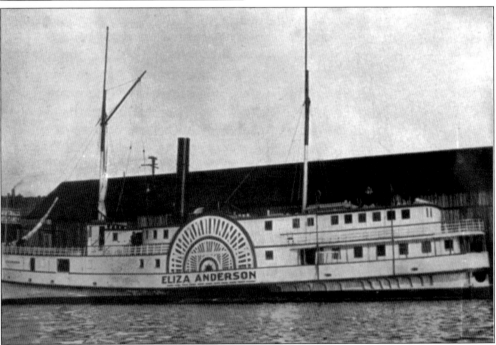

The 140-foot side-wheeler *Eliza Anderson* began on the Olympia to Victoria, British Columbia, route in 1859 and ran for many years. One of her pilots was "Captain" John Butler of Port Townsend, originally an Olympia farmer who was indicted but never tried for the murder of Tlingit chief Tsus-sy-uch at Butler's Olympia area farm in 1854. The farm, on the Budd Inlet cove now named for Butler, was sold by him to well-known early Thurston County settler William Winlock Miller.

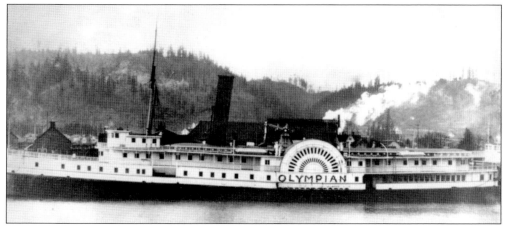

This "stately and beautiful side wheeler," the *Olympian*, is part of the tale of two "Olympians." As described by maritime historian Gordon Newell, the iron-hulled *Olympian* was built in Wilmington, Delaware, in 1883, her length of 262 feet making her among the largest of the Mosquito Fleet. The luxurious steamer with her big walking-beam engine ran the Olympia-Victoria route. She was faster than her rival, the *North Pacific*, on the Victoria run. Her salon was 200 feet long, with crystal lamps and Wilton carpets, 50 deluxe staterooms, and curved stairways inlaid with polished ebony. (Courtesy of Washington State Archives.)

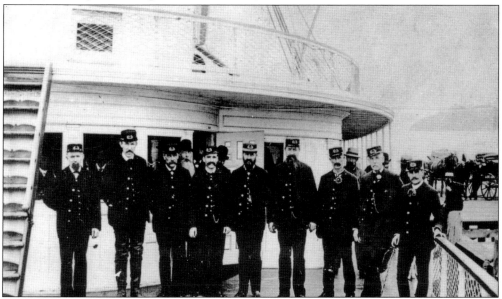

The officers of the opulent *Olympian*, some shown here, were numbered by the dozens. The Mosquito Fleet officer corps had a high turnover rate. *Olympia*'s officers included, as a sample, Captains O.A. Anderson, John Dixon, and A.F. Hennessey. Engineers included Charles J. Clark, Alexander Cummings, and Scott DeLauncey. Henry Carstens served as purser and Angus McCulcheon as steward. They did their best to make the steamer a paying vessel to operate, but she was extremely expensive to run, lost money, and went to the Columbia River in 1887. She returned to Puget Sound's Victoria run, was eventually laid up, and then on her way back to the Atlantic sank in the Straits of Magellan. She was remembered fondly for many years, as Gordon Newell described her, "the stately roll of her paddles and the ponderous curtseying of the walking-beams." (Courtesy of Washington State Archives.)

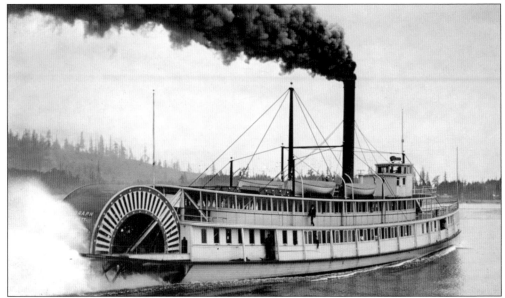

The stern-wheeler *Telegraph* was built in Everett in 1903. *Telegraph* had no direct connection to Olympia, except the circumstances of her curious renaming later, which resulted in her becoming the second *Olympian*. *Telegraph* was a fast, 750-horsepower passenger steamer that could do 18 knots. Her officers included Capt. Gil Parker and engineer B. van Hein. In 1912, she was secured at Seattle's Colman Dock when the steel-hulled *Alameda*'s engineer mistook "slow astern" for "full speed ahead" and rammed full speed into *Telegraph*, sinking her. She was raised, renamed *Olympian*, converted to a towboat, and ended her days on the Columbia River in 1924. Yet another *Olympian* was a propeller diesel tugboat built in Olympia in 1907. (Courtesy of Washington State Archives.)

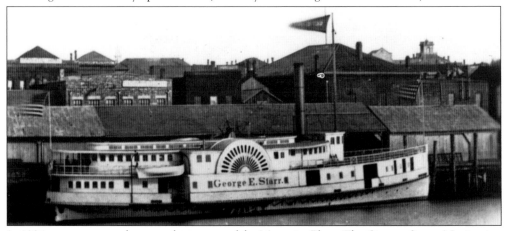

In 1884, a rate war raged among the owners of the Mosquito Fleet. The Oregon Steam Navigation Company, owned by E.A. and L.M. Starr, Portland businessmen, hit upon a scheme to knock out the Finch and Wright Company, owner of the *Eliza Anderson*. The Starrs' flagship, the side-wheeler *George E. Starr*, was much faster than the *Anderson*. The *Starr* would stalk the *Anderson* on every stop of the Olympia-Victoria run and at the last minute, as crowds waited to board the next boat, would speed ahead of her rival and board the bulk of the waiting passengers. The *Starr* was built in Seattle in 1879, a fast steamer but one that rolled badly in any kind of sea. She confined her runs to the South Sound and, in 1911, moved to the calmer waters of the Columbia River. (Courtesy of Washington State Archives.)

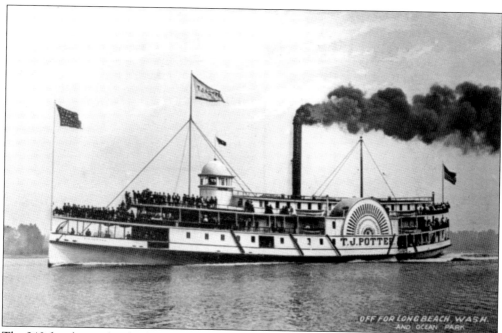

The 240-foot-long side-wheeler *T.J. Potter* was one of the fastest steamers on the Olympia-Tacoma-Seattle run. She was built in Portland in 1888, sailed on the placid waters of the Columbia River, and then spent two years in Puget Sound, including service to Olympia. *Potter* rolled horribly, described as "cavorting" by Gordon Newell. She returned to the Columbia River and served until 1920. Her name is inscribed on Olympia's Percival Landing Kiosk, which honors vessels of the Mosquito Fleet that served the state capital. (Courtesy of Washington State Archives.)

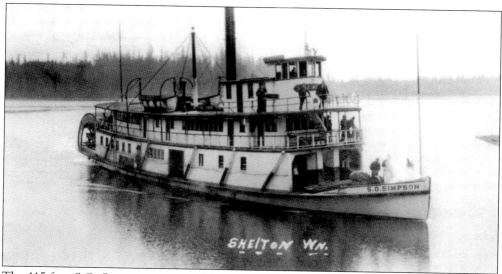

The 115-foot *S.G. Simpson* was named for a Mason County logging magnate and was built by Crawford and Reid Shipyard of Tacoma in 1907. She served the tortuous waters of Hammersly Inlet on the Shelton-Olympia run until 1927, when she was converted to a Skagit River towboat. She was the last stern-wheeler on the Shelton-Olympia route. (Courtesy of Kae Paterson.)

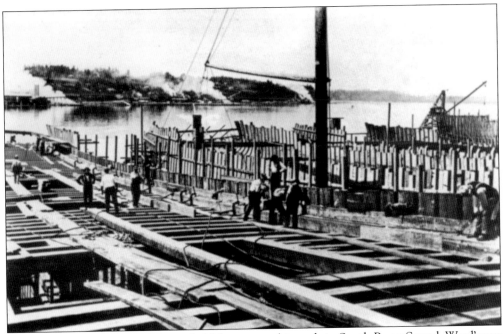

One of a number of late-19th- to early-20th-century shipyards in South Puget Sound, Ward's was located on the present site of the Port of Olympia, which was organized in the 1930s. (Courtesy of Shanna Stevenson and Henderson House Museum and Chuck Fowler.)

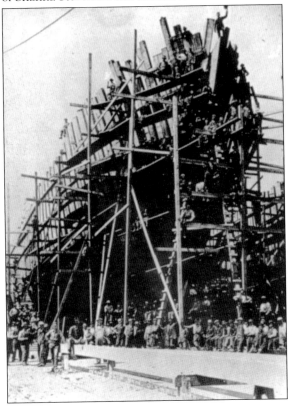

Later, the Olympia Shipbuilding Company occupied the same site. Auxiliary schooners were built here for the Army Transportation Corps during World War I. Shown here is a worker, waving his hat from a schooner under construction. (Courtesy of Shanna Stevenson and Henderson House Museum and Chuck Fowler.)

The 55-foot *Mizpah* was built in Olympia in 1901. She carried freight and passengers on the Olympia-Kamilche-Oyster Bay mail route until 1915, when she was rebuilt as a steam tug for the Capital City Tug Company of Olympia. Her later owners included Volney Young and Doc and Mark Freeman. (Courtesy of Kae Paterson.)

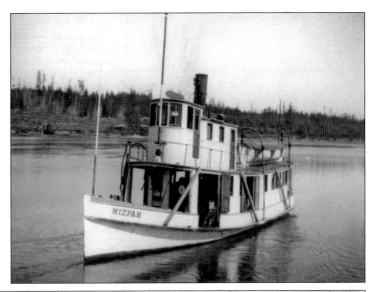

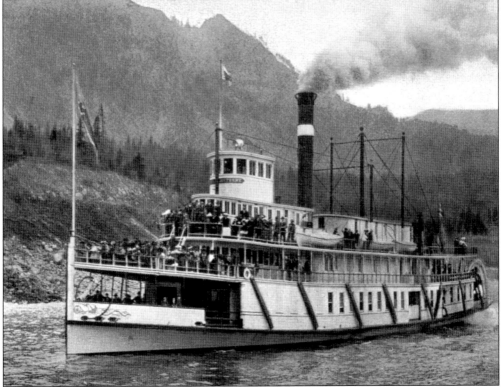

The stern-wheel steamer *Bailey Gatzert* was built in 1890 in Ballard and, for two years, ran the Olympia-Tacoma-Seattle route before being moved to the Columbia River as an excursion boat on the Portland-Astoria route, where her classy interior and speed made her immensely popular. She was named for a former Seattle mayor and, in 1917, was purchased by the Puget Sound Navigation Company and returned to Puget Sound for the Seattle-Bremerton run. "Tall and elegant," Olympia historian Gordon Newell commented, "she raced like a foam-tracked express" at 18 knots, one of the faster boats on the sound.

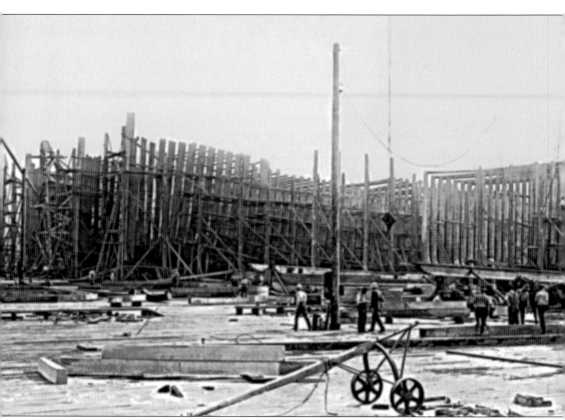

Shipbuilding was widespread in South Puget Sound. Among the most notable were Ward's and Olympia Shipbuilding Company on Budd Inlet, where schooners were built in 1917 for America's World War I effort. The site was constructed on materials from the Carlyon Fill. The popular site was later home to a third company, Sloan Shipyard. (Courtesy of Port of Olympia.)

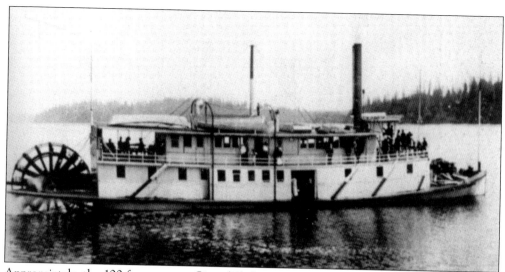

Appropriately, the 100-foot steamer *City of Shelton* was built in Shelton (1895) and ran on the Shelton-Olympia run. She was often in competition with a tiny screw steamer, the *Marian*, which had an experimental triple expansion engine that drove her very fast, small as she was. *Marian's* crew delighted in calling the *City of Shelton* "Old Wet-Butt," due to the spray of her stern-wheel. One Friday night, both boats were loaded with loggers yearning for the bright lights and bars of Olympia. They raced from Shelton down Hammersly Inlet to Budd Inlet, where the *Marian*, ahead, was running her engine at an unsafe speed and snapped her shaft. Her stern-wheel rival ignominiously towed her into Olympia, and everyone headed for the Pine Tree Saloon. The rough-hewn skipper of *City of Shelton*, Ed Gustafson, was a beloved figure among his logger passengers. (Courtesy of Washington State Archives.)

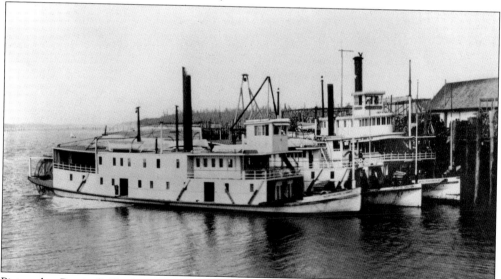

Pictured at Percival's Dock are *City of Shelton*, *Northern Light*, and the *Multnomah*. The 120-foot *Northern Light* was designed for the Yukon gold rush, but she never left Puget Sound, running from Shelton for much of her career. The 143-foot *Multnomah* was built in 1885 for the Willamette River in Oregon and purchased by Olympia's Willey family for the Olympia-Seattle run in 1889. In 1911, she was sunk by collision with the steamer *Iroquois* in Elliott Bay, Seattle. (Courtesy of Washington State Archives.)

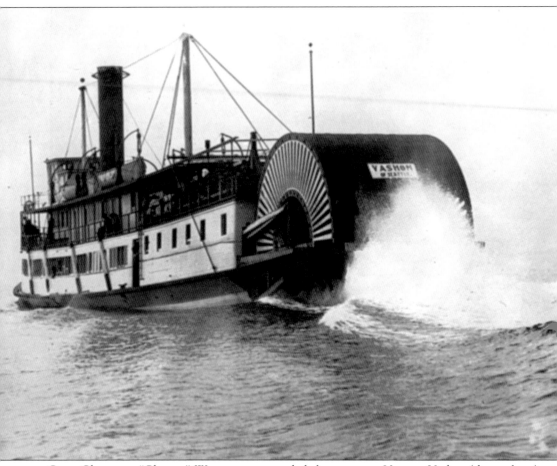

Capt. Chauncey "Chance" Wyman commanded the steamers *Verona*, *Vashon* (shown here), *Messenger*, and *Clara Brown*, all frequently on the Olympia-Seattle run. His wife, Gertrude, was the first woman licensed as a steamboat commander in Puget Sound. He was known as a "dog-bark skipper" and, when commanding the steamer *Sophia*, had trained his dog to bark during foggy days. Wyman would steer for the dog's barking on his home port dock at Quartermaster Harbor, finding it in the fog. Once, the dog was chased from the dock by a waiting passenger who had grown tired of the yapping, and the dog ran up the beach. Wyman ran the *Sophia* aground trying to follow the bark.

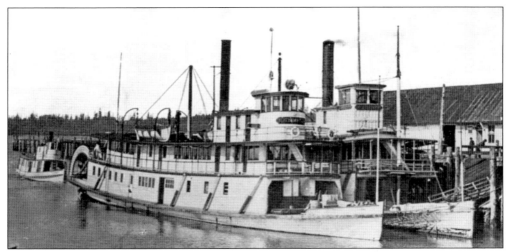

In 1860, Sam Percival and his son built this dock, which served as the primary access to Olympia until the advent of the automobile. It could accommodate shallow-draft steamers. Pictured here are three, the *S.G. Simpson*, the *Multnomah*, and astern the *Mizpah*. Other docks were built nearby to serve the capital city: Gidding's Dock in 1854 and Brown's Wharf in 1875. (Courtesy of Washington State Archives.)

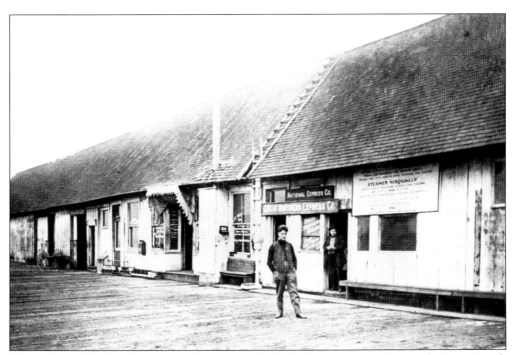

The dock built by Sam Percival and his son was the hub of commerce on the South Puget Sound. In addition to the many steamers calling there, numerous companies had their headquarters on the dock. National Express, a shipping company, was one. (Courtesy of Port of Olympia.)

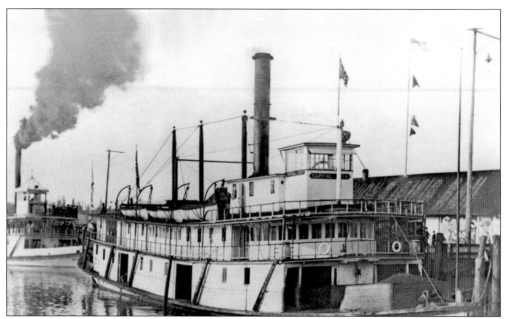

The steamship *Capital City* was a frequent Olympia-run stern-wheeler and could transport 300 passengers. She is pictured here at Percival's Dock on Olympia's Budd Inlet. Her route often included a popular stop at Boston Harbor, near the inlet's mouth. Along with the S.G. *Simpson, Bailey Gatzert, Mizpah, Fleetwood*, and *Greyhound*, she was known as a "fast boat," and races for bragging rights as "speediest boat" were common. (Courtesy of Washington State Archives.)

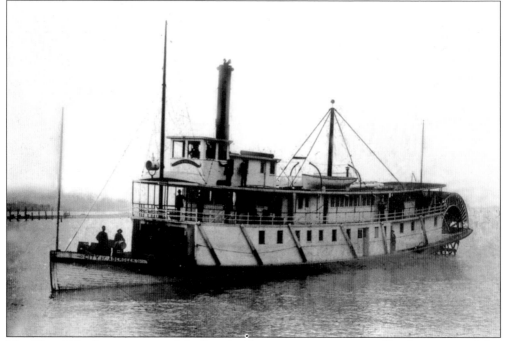

The *City of Aberdeen*, a veteran of the Seattle-Olympia run, was captained by the notorious John T. "Hell-roarin' Jack" Shroll, who never met a dock he could not destroy and who loved to race. Steamship skippers in Puget Sound were a competitive lot. (Courtesy of Kae Paterson.)

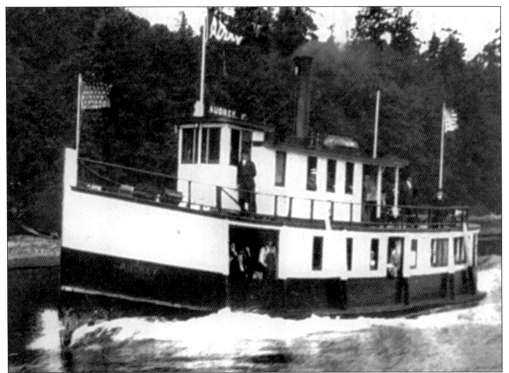

Many steamers were later converted to towboats after passenger business dropped off post World War I due to better roads and motor vehicles. The *Audrey* was an example. She was built in 1909 and ran from Anderson Island in the Nisqually Reach to Pierce County's Key Peninsula. In 1947, she was purchased by Delta V. Smyth, a well-known Olympia tug company owner, who converted her to a tug. (Courtesy of Kae Paterson.)

Delta V. Smyth sold his tug boat fleet, including the converted steamer *Audrey*, to Foss Towing Company in 1961. The Smyth family, including son Wayne and granddaughter Sarah Smyth-McIntosh, has remained connected to the towing industry. The family is a strong supporter of the Kiwanis-sponsored vintage tug race and festival, Olympia Harbor Days, held every Labor Day weekend and in its 44th year. (Courtesy of Kae Paterson.)

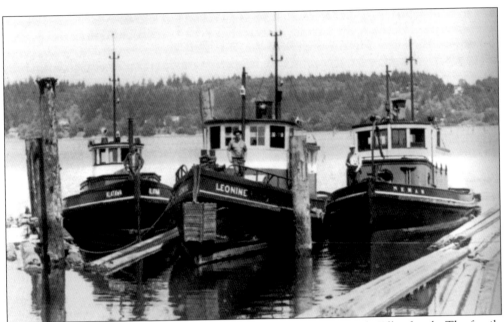

The Olympia Towing Company was an enterprise of Olympia's Samuel Willey family. The family owned towboats for three generations. Samuel's sons Lafayette and George carried on the family tradition. The company and the three tugs pictured here were sold in 1989 to Dunlop Towing of La Conner. Dunlop's tugs are frequent participants in the Olympia Harbor Days tug races. (Courtesy of Mark Freeman.)

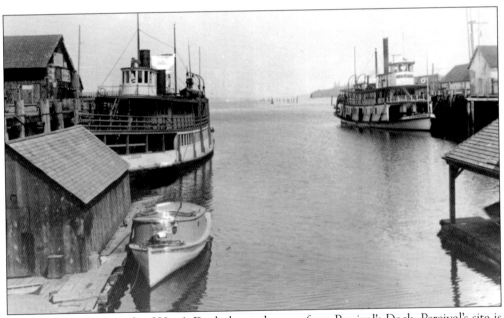

This is a rare photograph of Horr's Dock, located across from Percival's Dock. Percival's site is now the city-owned Percival's Landing, and the Horr's site is now where the Olympia Yacht Club is located.

This painting is by Karla Fowler, a widely admired marine artist whose paintings grace many a gallery and private collection. For many of Olympia Harbor Days' 44 years, she has drawn the logo, which shows a selected vintage tug participant, for each race. *Favorite* was the "logo tug" for the 2005 race. *Favorite* was built in 1937. Fowler's painting is of *Favorite* in the 1983 race. It is in the collection of Phil Martin, of Friday Harbor. The late Bill Somers featured it for years in his Stretch Island Museum of Puget Sound, which was located near Grapeview, Washington. (Courtesy of Karla Fowler.)

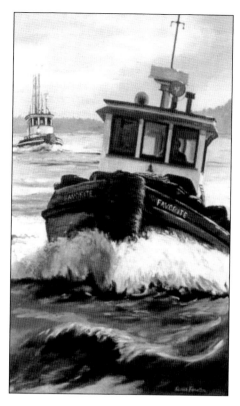

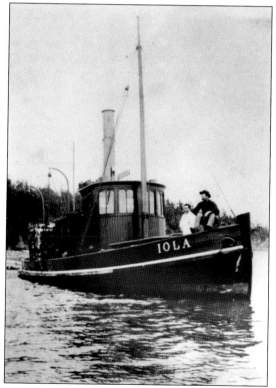

Built in 1885 on Hammersly Inlet (also known as Big Skookum Inlet), the 64-foot *Iola* ran the Olympia-Vashon-Seattle route until 1915. One day, off Vashon Island, Capt. John Vanderhoef's wife fell overboard while shaking out a tablecloth, unbeknownst to her husband. Thomas Redding, on shore, heard her cries for help and rescued her from his skiff. Two years later, Redding bought *Iola* and is pictured here, sitting on the bow. (Courtesy of Kae Paterson.)

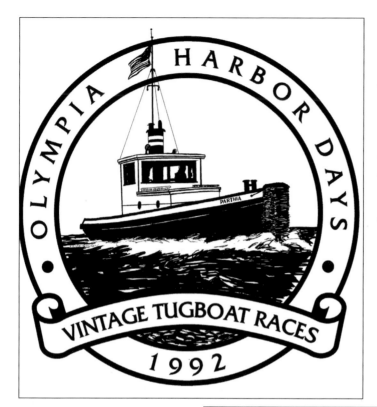

Parthia is another of Karla Fowler's "logo tugs," representing the 1992 Olympia Harbor Days. She was built in Olympia in 1906 and is still towing. *Parthia* was not only a 2016 Harbor Days winner (first in the "under 400 horsepower" race), but she was sold to a new owner during the festivities. (Courtesy of Karla Fowler.)

All five *Virginias* were owned by Nels Christensen, the first in 1908. The *Virginia V* is still afloat, built in 1922 and now owned by an historic foundation and active as a charter vessel on Puget Sound. She is one of the last survivors of the Mosquito Fleet and still a frequent visitor to Olympia, often during the annual Kiwanis' Olympia Harbor Days tugboat races on Labor Day weekend. The Mosquito Fleet refers to the hundreds of steamships that were Puget Sound's main means of transport from 1850 until the 1900s, so called because they "buzzed around" the sound like mosquitoes. The *Virginia V* is pictured here in an early configuration from the 1930s. (Courtesy of Washington State Archives.)

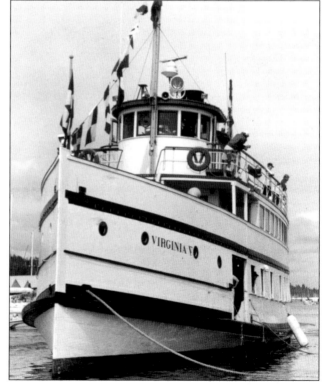

Built in 1926 and homeported in Olympia for much of her career, the *Tarry Not* is owned by Thurston County seafood company owner Steve Wilcox, seen here waving from the *Tarry Not* with the other survivor of the Mosquito Fleet, *Virginia V*, in the background. *Tarry Not* also serves as the Sea Blossom Seafood's company boat. She was originally a freight and passenger steamer, often calling at Arcadia in Mason County. The late Franz Schlottman, onetime owner of the 1910 tug *Sand Man*, used to ride her as a 10 year old to Olympia from his Griffin Peninsula home. Joe Bucannon was one of her first owners and could navigate her through dense fog, aided only by a pocket watch and a compass. (Courtesy of Steve Wilcox.)

In the 1940s, *Tarry Not* was rebuilt to the lines of a Monk cabin cruiser and left passenger service, as seen here. In the 1920s, she had roll-down canvas sides in the cabin, giving easier passenger access. She is actually *Tarry Not II*, as the first one was built in the 1890s, served Kamilche, and later had her boiler explode in Commencement Bay with no loss of life. (Courtesy of Steve Wilcox.)

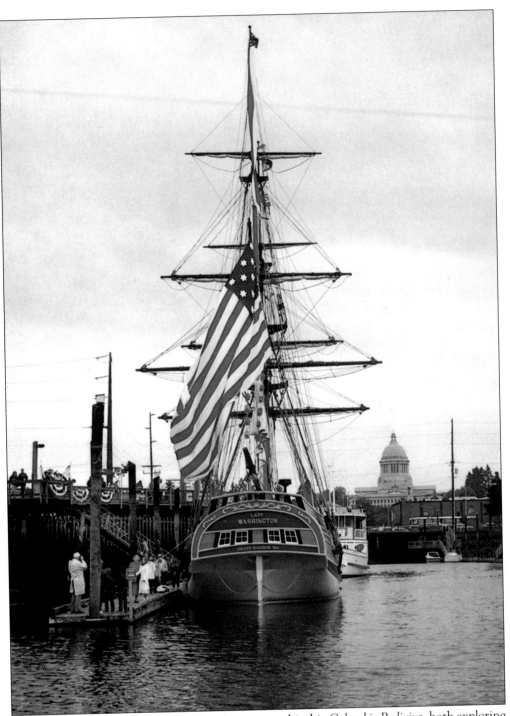

Lady Washington, a replica of Robert Gray's consort to his ship *Columbia Rediviva*, both exploring and trading here in 1792, was built during the state centennial celebration in 1989 and is owned by the Grays Harbor Historic Seaport. She is the State of Washington's official tall ship. She is a frequent visitor to Olympia Harbor Days and other events in the area. She has appeared in numerous motion pictures and television productions.

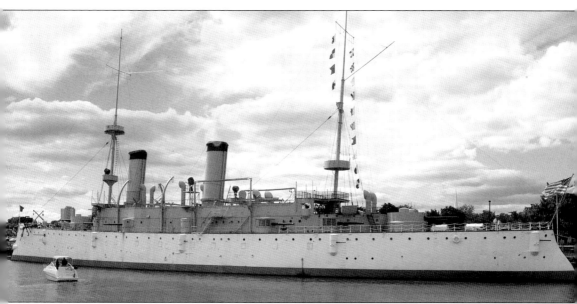

No examination of 19th-and-early-20th-century South Puget Sound maritime history is complete without a look at the USS *Olympia*. Although never a visitor to Puget Sound, her name ties her firmly to the region. She was designed in 1898, coincident with Washington statehood, and was Commodore George Dewey's flagship as his squadron destroyed the Spanish fleet at Manila Bay on May 1, 1898, a battle that gave birth to the American century. She fought with valor in World War I, intervened in the Russian Revolution, and in 1921, returned the body of America's first "Unknown Soldier" to the United States. Since 1957, she has been a museum ship at Philadelphia's Independence Seaport Museum on the Delaware River. Her silver tea service, on loan from the Navy, is in the Washington Governor's Mansion. An active citizen's group, the Washington State Friends of the USS *Olympia* (FOTO) strives to help maintain her and educate the citizens of the state as to her significant place in world history.

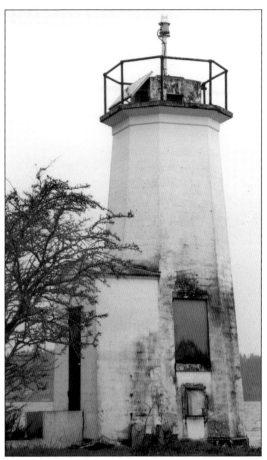

Dofflemyer Point Lighthouse is the first thing a mariner sees entering Budd Inlet by night. Isaac Dofflemyer established a land grant claim in 1865 at what was then known as Brown's Point, named by Wilkes in 1841 after his carpenter's mate, James Brown. A light came in 1887, and with increased shipping to Olympia, the current concrete structure with a foghorn was built in 1934. It was first maintained by local contractors and is now tended by US Coast Guard buoy tender crews. (Photograph by John Hough.)

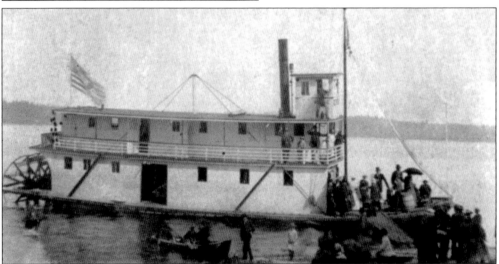

Another steamer owned by the Samuel Willey family, *Willie* was a 67-foot stern-wheeler built in Seattle in 1883 for use on the Nooksack River near Bellingham in Whatcom County. The S. Willey Navigation Company bought her to replace a smaller steamer on the Shelton-Olympia run. (Courtesy of Mason County Historical Society.)

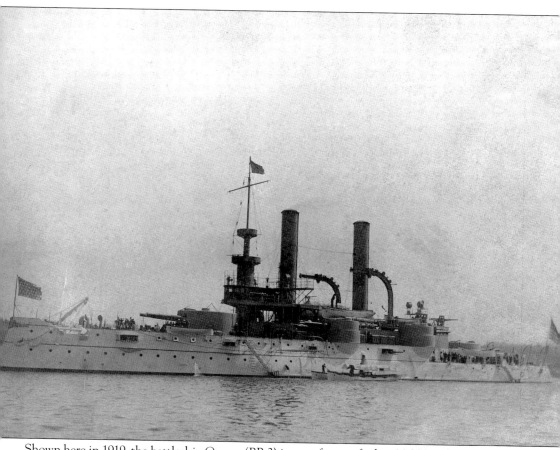

Shown here in 1919, the battleship *Oregon* (BB-3) is most famous for her 14,000-mile dash around South America from San Francisco to join the US fleet at their victory over Spain at Santiago Bay, Cuba, in the Spanish-American War in 1898. She is seen here visiting Olympia during the 1919 US Pacific Fleet Review Week in Seattle. *Oregon* was the president's review ship for Woodrow Wilson as he reviewed the fleet. It was protocol for the president to pay a courtesy visit to the governor of the state during a visit, hence the presence of his flagship in South Puget Sound. *Oregon* was also in Puget Sound on four occasions from 1901 to 1923 for refits at Bremerton Naval Shipyard. (Courtesy of Olympia Tumwater Foundation, used by permission.)

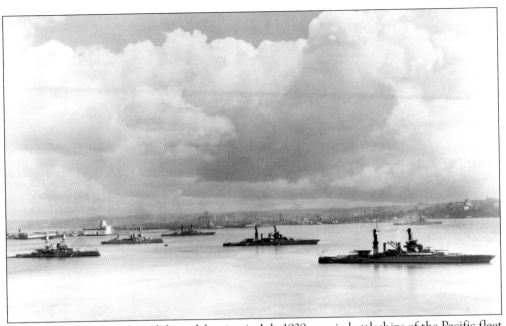

Washington State's golden jubilee celebration in July 1939 saw six battleships of the Pacific fleet drop anchor in Tacoma's Commencement Bay for a week. Five are pictured here. The battleships were the *Idaho*, *New Mexico*, *Mississippi*, *California*, *Pennsylvania*, and *Arizona*. The latter three were at Pearl Harbor on December 7, 1941. The USS *Arizona* was lost. The *Pennsylvania* and *California* were raised and refitted at the Puget Sound Naval Shipyard. (Courtesy of Tacoma Public Library.)

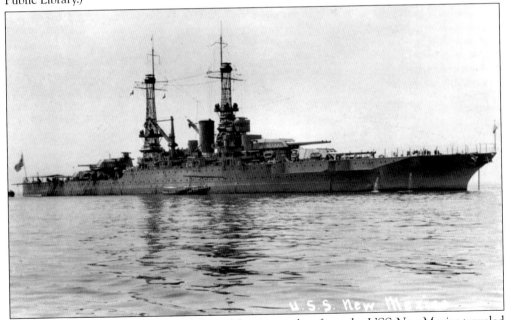

While in Tacoma for the golden jubilee celebration, sailors from the USS *New Mexico* traveled up Puget Sound to Thurston County's Saint Martin's College (now St. Martin's University in Lacey, Washington) for a baseball game against a student team. The score was not recorded. (US Navy photograph courtesy of NavSource Online.)

Four

State Capital Seaport
Developing World Trade, 1922–1973

Sailing vessels and Mosquito Fleet steamers served a growing Olympia, but mudflats that pushed out into Budd Inlet deterred oceangoing steamers from calling at the capital city. But at the turn of the 20th century, extensive dredging deepened the harbor and created new uplands to provide a practical ocean-wide outlet for local goods.

Timber products were, and are today, a major portion of the Olympia area's economy. By 1922, there were 30 lumber mills, five shingle mills, and a veneer plant on the shoreline near Olympia. In addition, local farms grew a wide variety of berries, which were canned for shipment. Olympia Beer, brewed in nearby Tumwater, and succulent Olympia oysters were also shipped to customers worldwide.

To boost commerce, in 1922, the voters of Thurston County created the Port of Olympia, and the business promptly began building piers along the newly filled area. Oceangoing steamers soon began calling on Olympia. In 1927, ninety vessels tied up to the port's docks.

In the early 1930s, new port facilities were built under President Roosevelt's New Deal. During World War II, the port shipped large amounts of lend-lease equipment and material to Russia.

After the war, Budd Inlet became home to a naval reserve fleet of mostly freighters, which existed until 1972. During the Korean War, the port began a long relationship with nearby Fort Lewis, shipping men and equipment to the Far East and then other conflicts around the world.

During the 1950s, lumber shipments continued as the port's mainstay cargo. In 1956 alone, 161 million board feet of lumber were shipped. Two gantry cranes were installed in the early 1960s to expand the range of cargo handled.

The 1970s saw the move to containers to transport cargo aboard ships. While larger ports, such as Seattle and Tacoma, rebuilt themselves to handle containers, the Port of Olympia focused on cargos not suitable for containers. Lumber shipments remained a major focus, with log exports accounting for 98 percent of the port's maritime business in that period. But the port continued to expand its market by handling a wide range of cargo, as it does today.

During the 1960s and 1970s, there was a significant growth in recreational boating in South Puget Sound. Several new small-boat marinas were added or existing ones expanded. The venerable Olympia Yacht Club, founded in 1904, anchors the head of Budd Inlet.

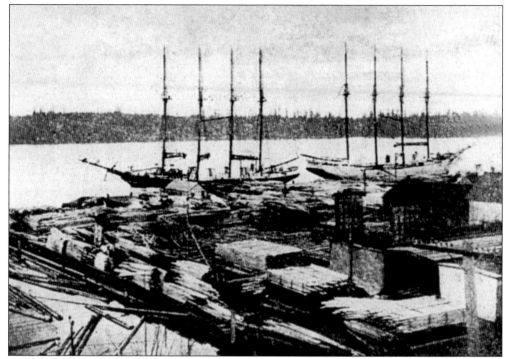

In the late 1890s, the Army Corps of Engineers began dredging operations to deepen the Olympia harbor. In this 1909 scene, two four-masted schooners are alongside a mill yard loading finished lumber bound for booming San Francisco. Several mills along the shore of Budd Inlet produced millions of board feet of lumber for San Francisco and overseas markets.

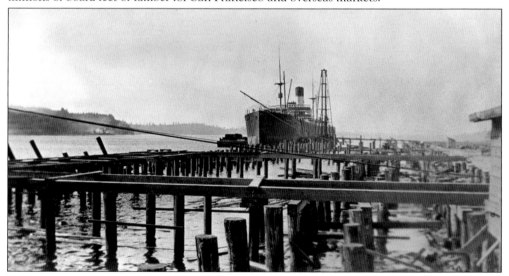

With the creation of the Port of Olympia in 1922, construction began of a pier and cargo storage facilities. The port facilities were built on a peninsula formed by the spoils from earlier dredging operations. However, oceangoing ships did not wait until the pier was completed. MS *Saginaw* was the first vessel to call at the port with the pier still under construction. The steamer loaded 70,000 board feet of finished lumber. By 1924, Olympia boasted thirty lumber mills, five shingle mills, and a veneer plant.

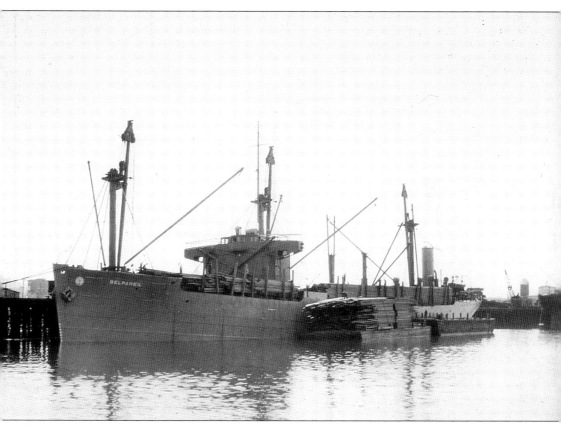

The Norwegian vessel MS *Belpareil* is shown loading lumber from a barge in October 1927. Although the port's pier was finished, it was more convenient for the mills to barge lumber across Budd Inlet to be loaded on ships. *Belpareil* sailed to Antwerp with 6.2 million board feet of lumber—the largest cargo at the time from any port on the West Coast to Europe.

Powerboats jockey for position at the starting line on June 26, 1928, for the longest, most ambitious powerboat race ever staged up to that time. The Capital to Capital race from Olympia to Juneau covered 1,000 miles through the Inland Passage. Adolph Schmidt, the founder of Olympia Brewing Company, and businessman John Pierce organized the predicted-time race. In the small boat division, *Dell* won with the run closest to predicted time. It was the first race run under sanction of the Pacific Coast division of the American Powerboat Association. (Photograph by Maurice Anderson, courtesy of the Olympia Tumwater Foundation, used with permission.)

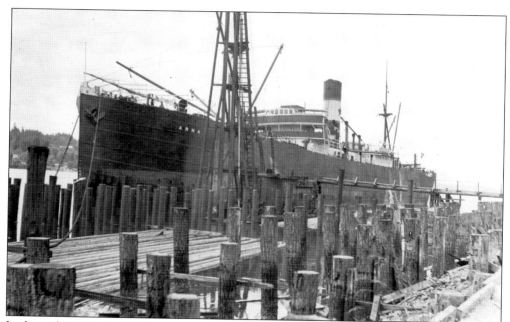

In the early 1920s, the MV *Arna* was moored to the port's pier, still under construction. Note the long gangway across the unfinished pier. Logs are being loaded from the ship's outboard side.

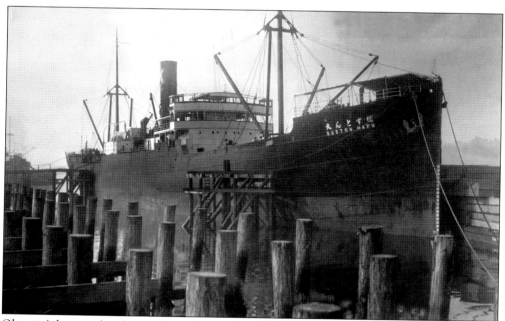

Olympia's long trade relationship with Japan began in the early 1920s. Here, the *Boston Maru* is loading lumber from a barge alongside her at the still unfinished pier.

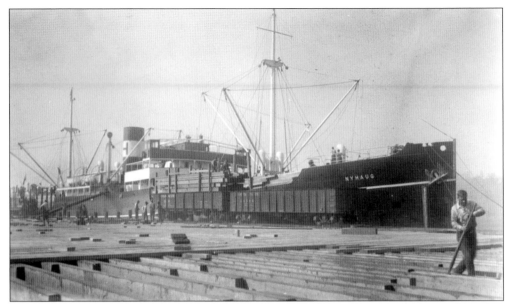

The Chinese steamer *Nyhaug* is alongside the port's pier, still largely unfinished. A rail line has been run out to ease loading and unloading. Here, large wooden beams from one of the Budd Inlet mills are being loaded.

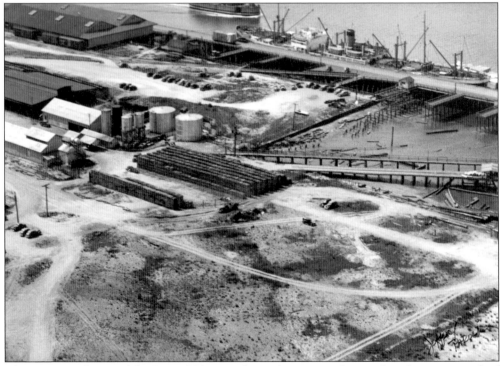

This 1929 aerial view of the Port of Olympia shows the pier nearly complete, however, much of the dock area still needs to be filled in. The upland has become as much an industrial site as a cargo-loading facility.

By the early 1930s, the port's pier is finished, with space left open for later expansion. Here, the MV *Knudson* is awaiting logs to be rafted alongside her. The ships of the era mounted their own cargo booms because many ports, including Olympia, did not yet have their own cranes.

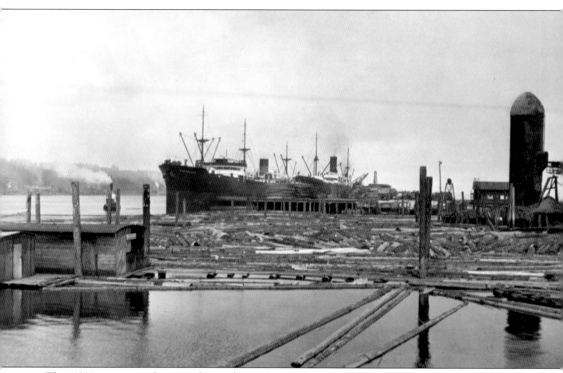

This 1930s scene at the port shows the cycle of logs rafted into a millpond, sawed into finished lumber at the mill, and loaded aboard ship for export. The large conical structure was used to burn the leftovers from sawing. Olympia is the closest major port to southwest Washington's vast timber resources. By the late 1920s, Olympia had become a major port for lumber being shipped around the world. In 1929 alone, the port shipped 228 million board feet of lumber and 9,000 pounds of general cargo aboard 224 oceangoing ships.

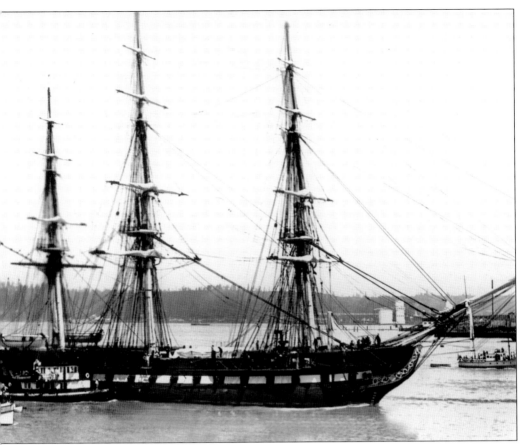

The historic frigate USS *Constitution*, also known as "Old Ironsides," visited Olympia in June 1933. She was on a tour of both coasts to thank the public for donations that enabled the badly deteriorated old warship to be rebuilt. Much of the construction funds came from schoolchildren donating pennies. Thousands turned out to visit her at each stop. The *Constitution*, built in 1797, became a hero of the War of 1812 when she defeated several British warships in English waters. She was called "Old Ironsides" because enemy cannon shot seemed to just bounce off her stout hull. Now moored in Boston, she is the Navy's oldest commissioned vessel still afloat. (Courtesy of Kae Paterson.)

The steamer *P&T Adventure*, heavily laden with finished lumber, has cast off from the port's pier and awaits tug assistance to turn around to head down Puget Sound and out to sea. The state's domed capitol building is in the distance, off the steamer's bow.

Few passenger vessels called at Olympia. Here is the stately Italian liner *Contessa D'Aosta* at the port's dock in the late 1920s. A number of local residents came to the dock to tour her.

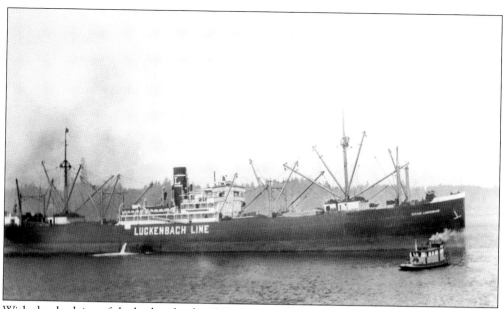

With the dredging of the harbor, by the 1930s large oceangoing ships regularly called at the port. The *Horace Luckenbach* was part of the Luckenbach Steamship Company, one of America's largest at the time. She sailed among Olympia, Seattle, San Francisco, and New York via the Panama Canal. Note the steam tug assisting in turning the ship so she can head out of Budd Inlet and down Puget Sound out to sea.

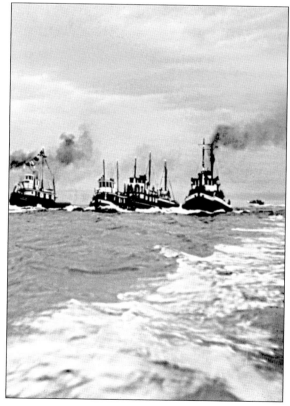

Tugs boats race up Budd Inlet in a scene for the 1933 movie *Tugboat Annie*, starring Marie Dressler, Wallace Berry, and Robert Young. The movie is very loosely based on the life of Thea Foss, who, with her husband, Andrew, created what became Foss Tug & Barge Co. Now Foss Maritime, it is the largest tug and barge company on the West Coast. (Courtesy of Deborah Haskett.)

The tug *Rustler* was a frequent visitor to Olympia, either towing in a raft of logs to be loaded aboard a ship or assisting one of the big oceangoing vessels in the turning basin so she could head north down Puget Sound and out to sea. Here, she is in her Foss Tug & Barge Co. colors. (Courtesy of Deborah Haskett.)

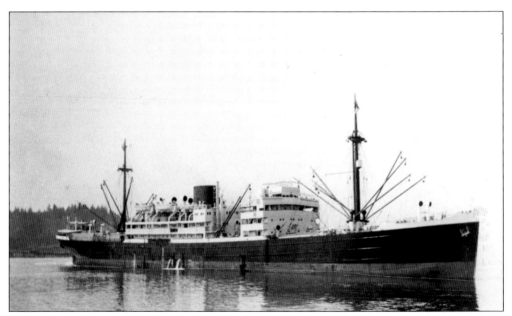

The steamer *Oregon* of the French Line idles in Budd Inlet waiting for space at the port's busy docks. She is a cargo ship but also has cabins amidships for passengers, often people on holiday content to go where ever the ship goes.

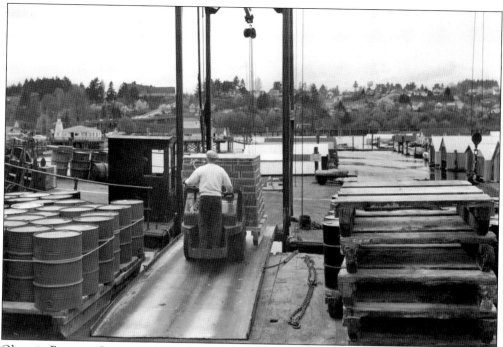

Olympia Brewing Company, located in Tumwater, was a major employer in the area. A worker loads cases of iconic Olympia Beer aboard a barge, probably bound for Alaska. (Courtesy of Olympia Tumwater Foundation, used with permission.)

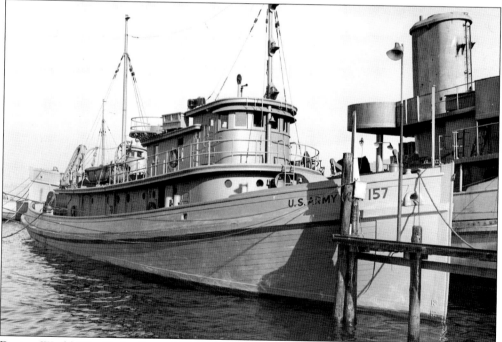

During World War II, the Port of Olympia was a major shipping point for war goods bound for Alaska and Russia. This Army tug was stationed full time in Olympia to assist the ships coming and going during the war. (Courtesy of Washington State Archives.)

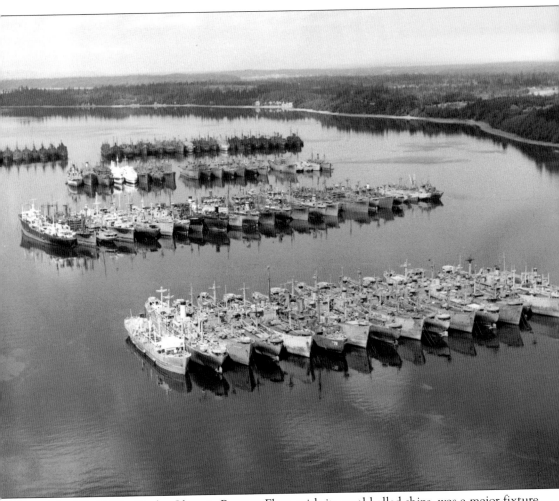

After World War II, the Olympia Reserve Fleet, with its mothballed ships, was a major fixture in Budd Inlet for several decades. With the end of the war, the US Navy had thousands of ships that were no longer needed. Some were quickly scrapped, but hundreds were placed in mothballs in harbors on both coasts in case they were needed again. In 1946, a reserve fleet was established in Gull Harbor, just north of Olympia. Rafted together were over 100 transports, tankers, and other vessels kept in top condition by the US Maritime Administration. Many of these vessels were called back into service during Korea, the Suez Crisis, and Vietnam. During the mid-1950s, some of the ships were used to store bumper crops of wheat. By July 1972, the last of these vessels was towed away for scrap. (Courtesy of Olympia Tumwater Foundation, used with permission.)

The Olympia Reserve Fleet required constant maintenance to be ready to deploy on short notice. The US Maritime Administration staff looking after the ships was housed in this headquarters building.

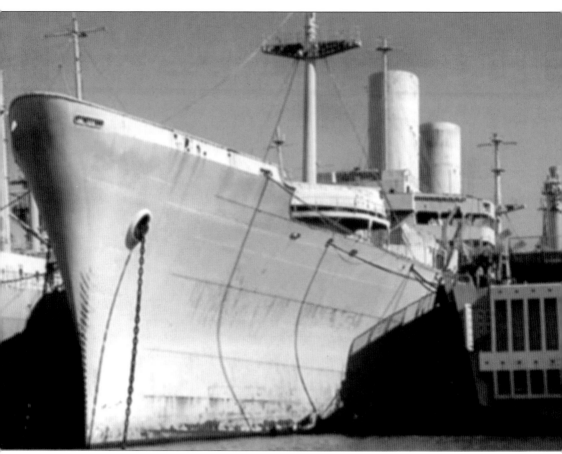

A typical vessel in the Olympia Reserve Fleet was the USS *General John Pope*. She was built at the outset of World War II as a troop transport. The *Pope* spent the war transporting troops to the South Pacific and home again after the war as part of Operation Magic Carpet. During the Korean War, she transported troops to Korea. In March 1958, as shown here, she was assigned to the Olympia Reserve Fleet. The *Pope* and several other ships in the Olympia Reserve Fleet were activated in 1965 to carry troops to southeast Asia during the Vietnam War. In 1970, the *Pope* was placed in reserve in California and scrapped in 2010. (Courtesy of US Navy, Naval Historical Center.)

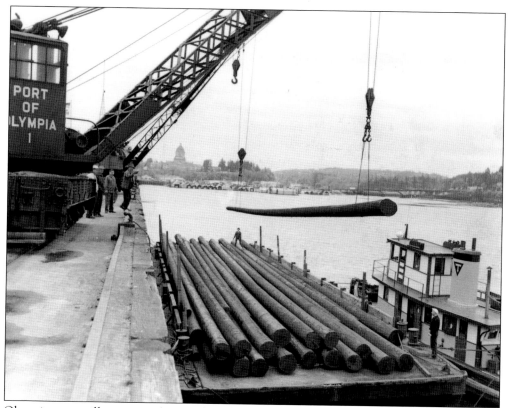

Olympia-area mills continued to produce finished lumber well into the 1960s. Here, wooden utility poles are being loaded onto a barge with one of the port's new cranes.

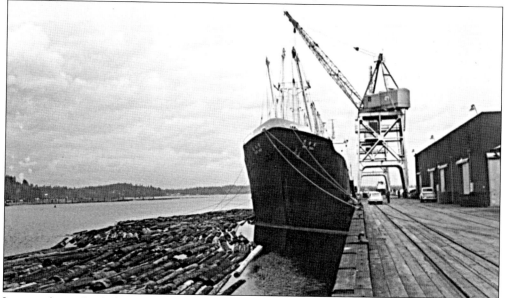

Logs are being loaded aboard a ship, probably bound for east Asia. Despite the port's large new cranes, it was usually more convenient to gather timber harvested in the region into large rafts to be towed up Puget Sound into Budd Inlet and nestled against a ship for loading.

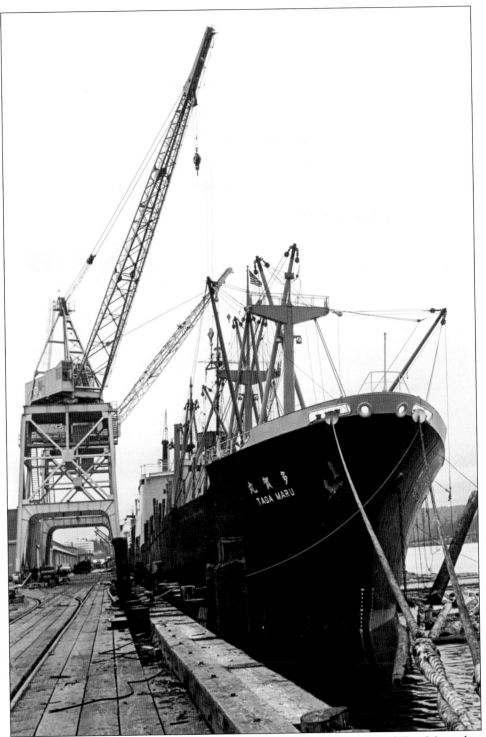

Trade with Japan became a mainstay of the port's business. The Japanese vessel *Taga Maru*, shown loading logs, was a frequent visitor in the 1950s and 1960s. On the pier next to the ship is a much larger crane installed by the Port of Olympia to handle heavier cargos.

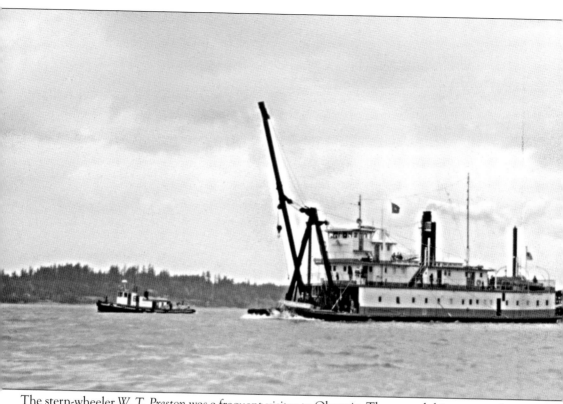

The stern-wheeler *W. T. Preston* was a frequent visitor to Olympia. The second ship to carry this name, the *W. T. Preston* was operated by the Army Corps of Engineers from 1939 until she was retired in 1981. Her initial job was to clear dangerous snags from Puget Sound and navigable rivers to ease passage for small steamboats. But her duties changed as roads developed and rivers were no longer used for navigation. *W. T. Preston* was put to work dredging and firefighting and even recovered a sunken airliner. She is now a National Historic Landmark on display in Anacortes, Washington. (Courtesy of Deborah Haskett.)

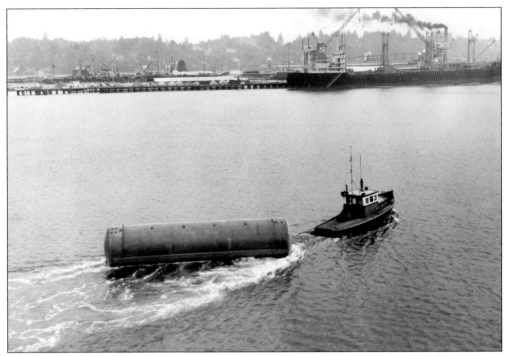

A steel fabrication plant was built across from the port in the 1950s on a former mill site. Here, a new holding tank for beer is being towed across the harbor to be installed at Olympia Brewery Company in Tumwater. (Courtesy of Olympia Tumwater Foundation, used with permission.)

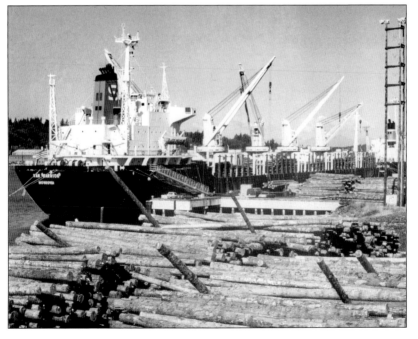

The *Van Warrior* loads logs at the Port of Olympia. The full log yard gives a sense as to how many logs it takes to make a full load for the log ships, which were growing larger and larger.

A Norwegian Hogue Lines ship loads pallets at the Port of Olympia, reflecting the port's continuing efforts to attract diversified cargo as containerization became the dominant way of shipping goods.

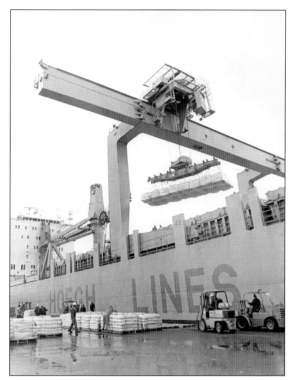

The Japanese merchant marine training vessel *Nippon Maru* visited Olympia at the invitation of the governor as part of Washington's 1989 centennial celebration. Even late in the 20th century, training officer candidates on sailing ships was a time-honored tradition.

As part of the tradition of naval vessels visiting Olympia, here a US Navy frigate is open for tours in the 1970s as part of Olympia's summer Lakefair celebration.

The Olympia Yacht Club, located at the very head of Budd Inlet, was founded in 1904. It grew out of the Boat and Rowing Club of Olympia. As the growth in recreational boating continued, the club grew to be the anchor of a number of small boat marinas in South Sound. (Photograph by John Hough.)

Wind power propelled the early explorers and remains a popular recreation. Here, sailboats head out into Budd Inlet for the start of the Wednesday night race series. (Photograph by John Hough.)

A winter Saturday race with good wind treats the crews to a view of the Olympic Mountains northwest of Olympia. (Photograph by John Hough.)

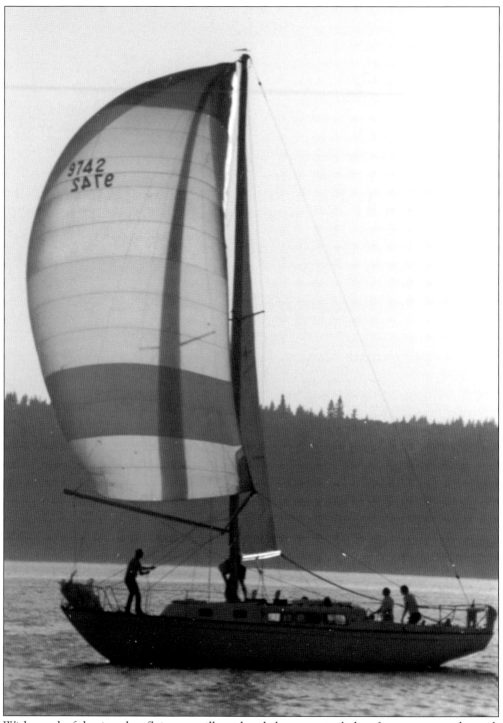

With a colorful spinnaker flying, a sailboat heads home at twilight after a summer day sail. (Photograph by John Hough.)

Five

THE CHANGING WATERFRONT AND OLYMPIA HARBOR DAYS
1974 TO PRESENT

As container ships became the standard means of transporting ocean cargo, the Port of Olympia carved out a niche focusing on cargos that do not easily fit into boxes. Timber shipments remain the core of the port's business. But the port handles a variety of other types of cargo. Also, the port continues its close relationship with nearby Fort Lewis, now part of Joint Base Lewis-McCord, handling shipment of military vehicles and supplies around the world.

Historically, much of South Puget Sound was a marine highway for transporting people and goods. But as Olympia and the surrounding area grew, recreational boating became an important contributor to the region's economy. Budd Inlet is home to several private marinas and one operated by the Port of Olympia. The Olympia Yacht Club was formed in 1904 by boating enthusiasts and still sits at the head of Budd Inlet.

Olympia Harbor Days has become the signature event celebrating South Puget Sound's maritime heritage. The festival began in 1974 when the owners of several historic tugs, steamboats, and sailing ships brought their vessels to Olympia to show the public the South Sound's maritime past. The following year, a Labor Day weekend tradition began with annual tugboats races sponsored for many decades by the South Sound Maritime Heritage Association, now by the Olympia Kiwanis. The largest gathering of historic tugs and other vessels was in 1989 to celebrate the State of Washington's centennial. Continuing today, these tugboat races recreate the days when tugs raced out to incoming sailing ships to win the right to tow the large vessels into port. Since 1979, a popular arts and crafts event has been held in conjunction with the display of historic tugs on Saturday and races on Sunday.

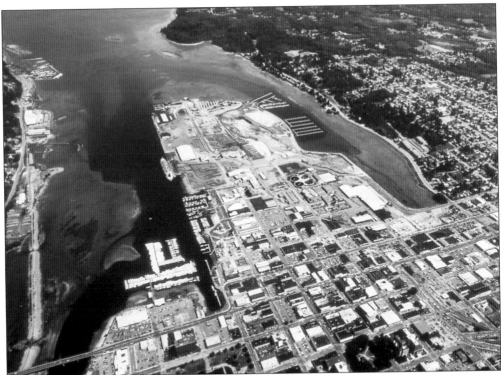

This 1960s aerial view of Budd Inlet shows the growth of the port along with the mudflats that need constant dredging to allow passage of oceangoing ships.

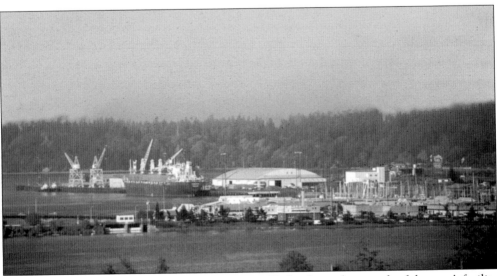

This panorama view of the port docks across Capitol Lake shows the growth of the port's facility since it was established in the 1920s.

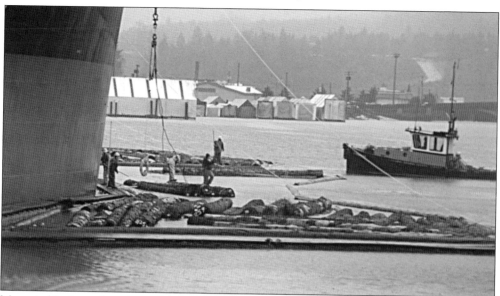

Men nimbly dance from log to log as timber rafted into Budd Inlet is loaded aboard a ship bound for east Asia. Log exports remain a major business for the Port of Olympia.

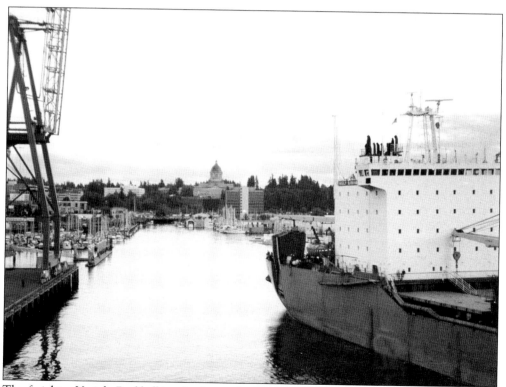

The freighter *Vasiula Burkhall* is edged into the Port of Olympia pier by assisting tugs with the state capitol building in the background. The ramp on her aft starboard side allows vehicles to be easily rolled on and off.

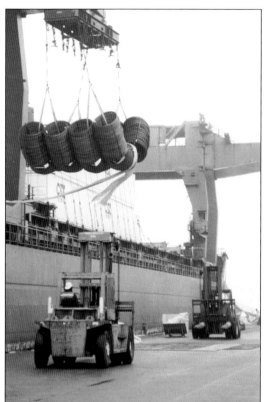

The Port of Olympia worked hard to expand its business beyond log shipments. The focus is on cargo that does not lend itself to shipping containers. Here, cable is being loaded for export.

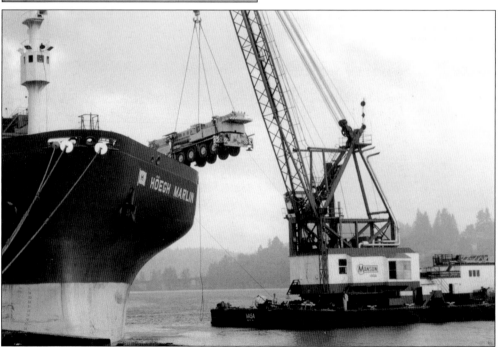

A new mobile crane is being unloaded at the Port of Olympia by Manson Construction's heavy lift crane *Vasa*, which was towed down from Seattle especially for this job.

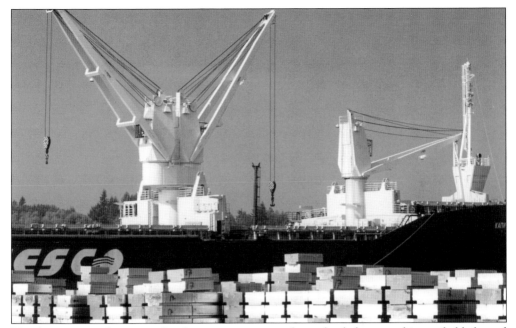

Metal ingots, another example of a unique cargo, are being loaded onto a ship, probably bound for a factory in east Asia.

Just unloaded at the Port of Olympia is this large sailing trimaran, probably custom built in Taiwan.

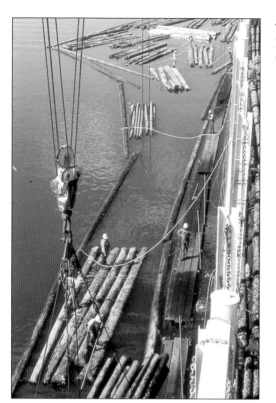

This bird's-eye view shows nimble longshoreman maneuvering rafted logs to load aboard a ship for export.

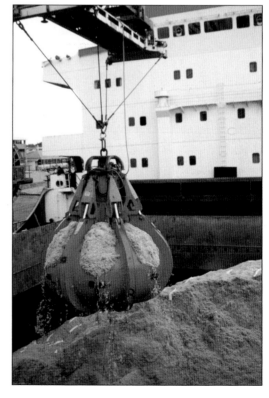

This dry bulk cargo being unloaded is a result of the Port of Olympia's efforts to attract cargo unsuited for the containerization ports in Seattle and Tacoma.

A shipload of finished lumber from Weyerhaeuser is ready to depart the Port of Olympia. While there are no longer any lumber mills on Budd Inlet, the port still handles finished lumber, as well as raw logs.

These large cradles make it easier to load raw logs for shipment.

Modern cargo ships calling at Olympia require larger tugs than were used even a couple of decades earlier. Here, a tug assists a large cargo ship as it pulls away from the port's pier to head down Puget Sound and out to sea.

The *UPC Savannah* lies fully loaded at the Port
of Olympia framed by the fast-growing fleet of
recreational boats that call Olympia home.

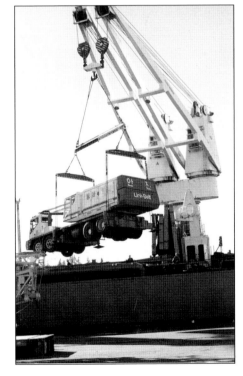

A new heavy-duty truck built by Link-Belt
Construction Equipment Company is being
loaded aboard a ship for export, showing the Port
of Olympia's niche handling of unique cargo.

The small tug *Cedar King* helps corral a raft of logs for loading aboard ship. Despite more modern ways of transporting logs from the forest to the port, logs are still transported the old-fashioned way—being assembled into rafts and towed up the sound to the port.

Continuing Olympia's close connection with the US Navy, the USS *Obendorf*, a *Spruance*-class destroyer, paid a port call on Olympia in the mid-1980s.

The USS *Olympia*, a *Los Angeles*–class fast-attack submarine, paid a visit to her namesake city shortly after her commissioning in 1986. She is the second naval vessel named after the capital city, the first being Admiral Dewey's flagship at the Battle of Manila Bay in 1898.

With her crew lining the rails in greeting, USS *Copeland* arrives in Olympia for a port visit during summer Lakefair festivities. She was an *Oliver Hazard Perry*–class guided missile frigate.

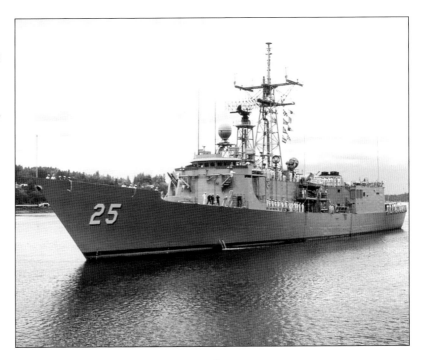

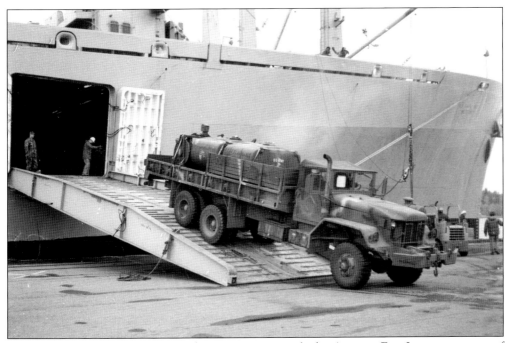

The Port of Olympia maintains a close connection with the Army at Fort Lewis, now part of Joint Base Lewis-McCord. A fuel truck is being backed aboard ship for transport to South Korea to take part in Team Spirit '84, a joint military training exercise between South Korea and the United States.

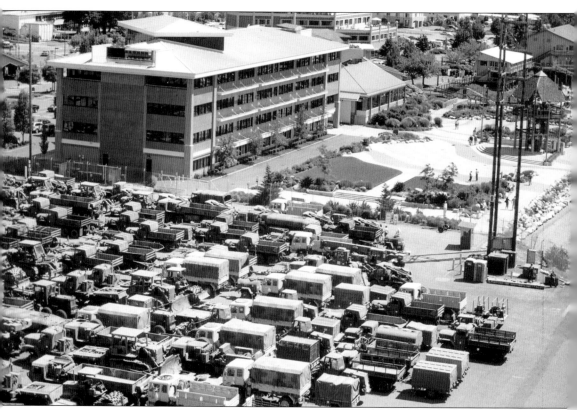

With war in the Middle East and Afghanistan, the Port of Olympia plays a key role in shipping military equipment overseas. These Army vehicles from Joint Base Lewis-McCord awaiting shipment show the scale of the mission.

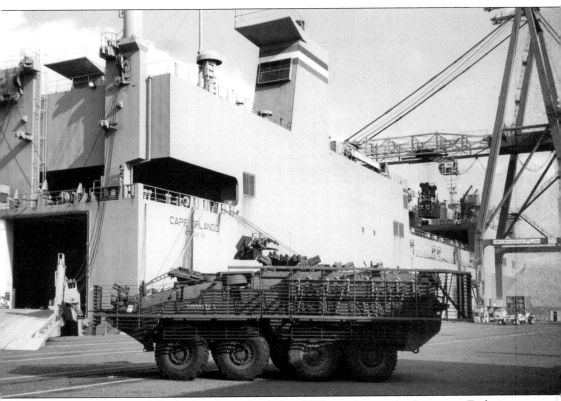

An Army Stryker armored vehicle is being loaded in 2002 to take part in Operation Enduring Freedom in Afghanistan. At the dock is MV *Cape Orlando*, a 635-foot "roll on-roll off" ship operated by the Military Sea Lift Command.

An Army CH-46 Chinook helicopter bound for the Middle East is ready to be loaded aboard MV *Cape Kennedy*, another vessel operated by the Military Sea Lift Command.

The US Coast Guard provides port security when military equipment is being loaded at the Port of Olympia.

The Army Corps of Engineers stern-wheeler *W.T. Preston* paid one last visit to Olympia before she was retired in 1981. She was the last stern-wheeler to ply Puget Sound, echoing the days when many of the early Mosquito Fleet vessels were propelled by stern-wheels.

The schooner *Adventuress* often calls on Olympia. She was launched in East Boothbay, Maine, in 1913 and brought around Cape Horn by a wealthy adventurer to hunt artic specimens for the American Museum of Natural History. Afterwards, she had a varied career, including serving for many years as a pilot boat in the San Francisco Bay. She returned to Puget Sound in 1952. A National Historic Landmark, she is now owned by the nonprofit Sound Experience, providing education for youngsters. (Photograph by John Hough.)

A cargo ship at the Port of Olympia dwarfs a sailboat heading out into Budd Inlet. Maritime use of South Puget Sound has evolved into a combination of commercial and recreational vessels.

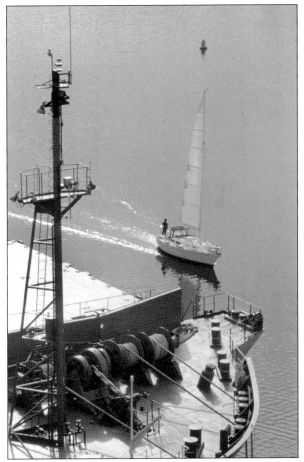

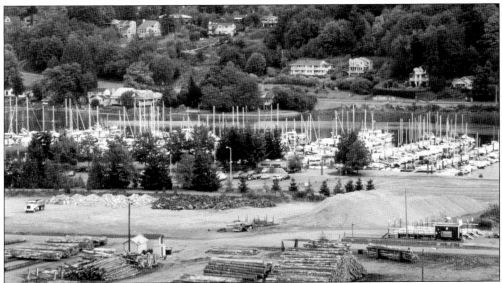

This view across the log storage yard of the Port of Olympia to its marina shows today's mixed commercial and recreation uses of South Puget Sound's waters.

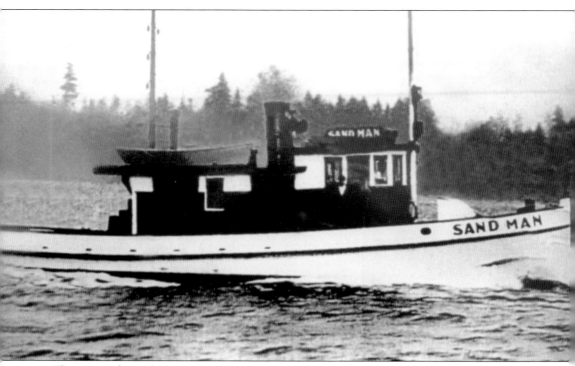

The tug *Sand Man* became an Olympia icon. Launched in 1910, she served in the Olympia area for many decades, towing log rafts or barges laden with building material. Here, she is pictured as she appeared early in her life. (Courtesy of Chuck Fowler.)

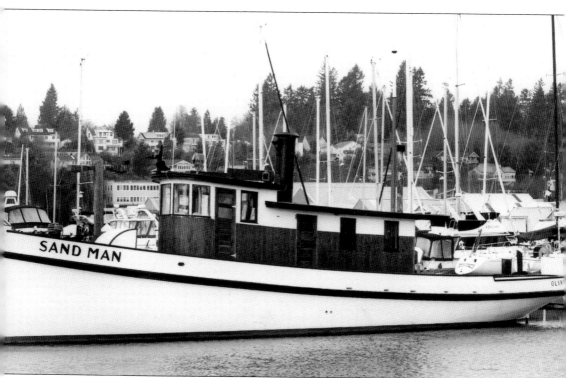

Over a century old, *Sand Man* is now moored in Olympia as a living reminder of the city's long relationship with commerce on South Puget Sound. Completely restored, she is open to the public. (Photograph by John Hough.)

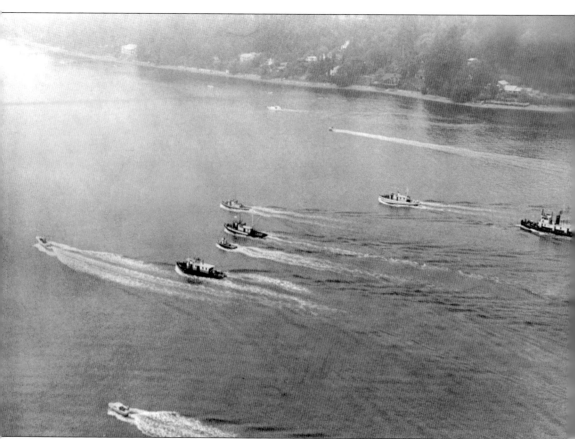

In 1975, the first annual Olympia Harbor Days festival was held in Olympia. Owners of vintage and modern tugs opened their boat for tours on Saturday. On Sunday, they raced down Budd Inlet for fun and bragging rights. Pictured is that first race. (Courtesy of Deborah Haskett.)

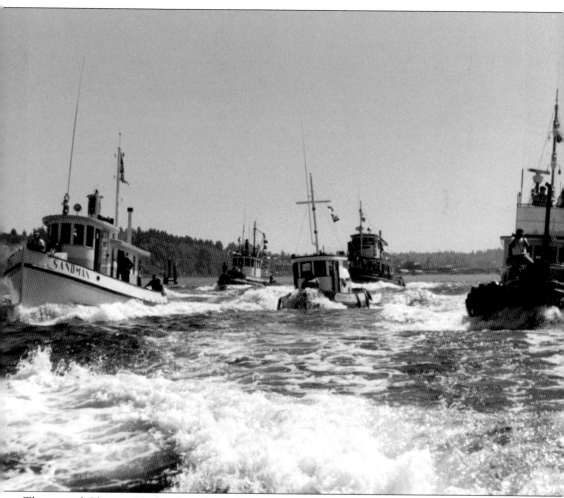

The annual Olympia Harbor Days festival continues from that initial meeting of tugs. Here, tugs charge up Budd Inlet during an early Olympia Harbor Days race. The classic tug *Sand Man* is holding her own against her newer-class competitors. (Courtesy of Deborah Haskett.)

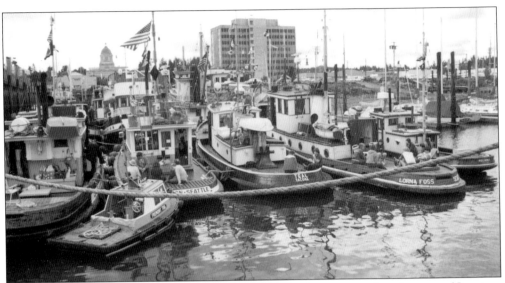

An early Olympia Harbor Days saw a large gathering of both vintage and modern tugs. (Courtesy of Deborah Haskett.)

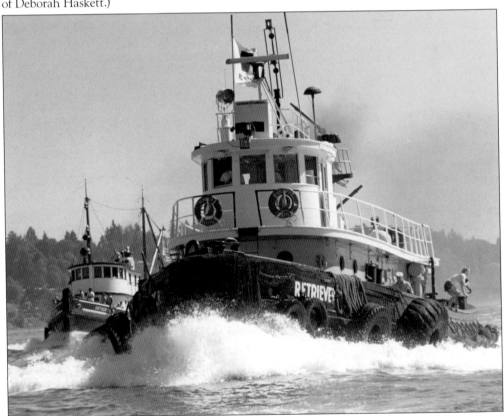

The powerful tug *Retriever* plows by the venerable *Arthur Foss* during an Olympia Harbor Days race. The *Arthur Foss* was built in 1889 and featured in the 1933 movie *Tugboat Annie*. She is a National Historic Landmark and part of the Northwest Seaport Museum in Seattle. (Courtesy of Deborah Haskett.)

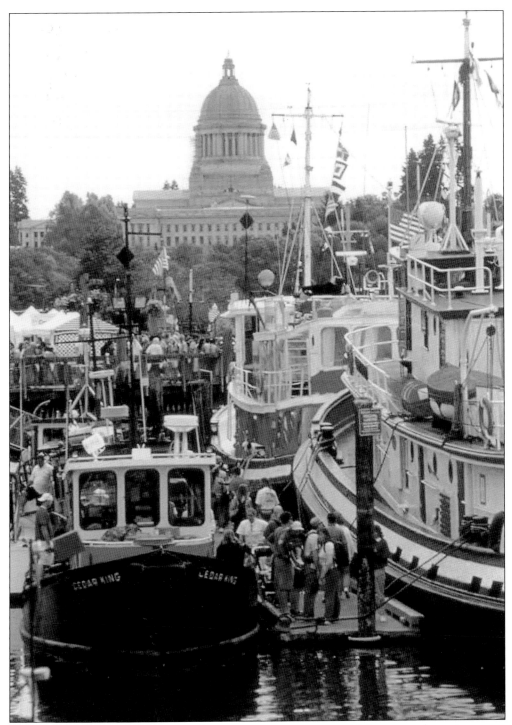

Olympia Harbor Days has become a favorite community event, with large crowds coming to see the tugs and stroll among vendors with a wide variety of arts and crafts spread along modern Percival Landing. (Courtesy of Chuck Fowler.)

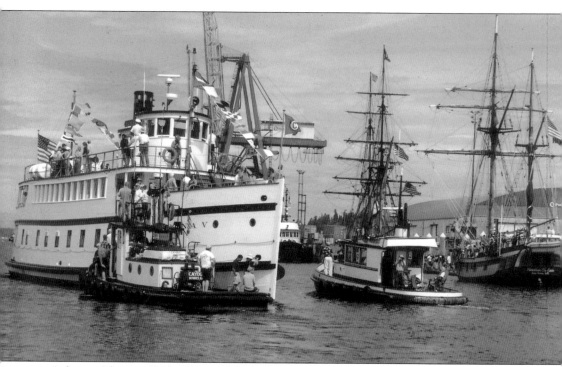

A festive Olympia Harbor Days celebration featured a visit by the vintage steamer *Virginia V* up from Seattle. Built in 1921, she is the last survivor from the days of the Mosquito Fleet. In the background is the tall ship *Hawaiian Chieftain*, and beyond her, the masts of *Lady Washington*, a replica of the consort of Capt. Robert Gray's ship *Columbia Rediviva* on his discovery of the Columbia River for America. (Courtesy of Chuck Fowler.)

A favorite Olympia Harbor Day event is teams racing in replicas of the longboats used by Lt. Peter Puget during his 1872 exploration of the South Sound that was named after him.

In 2006, St. Martin's University held the first annual dragon boat races on Budd Inlet. That year, only five teams competed. The sport, originally from China, has become very popular. Today, over 50 teams compete in this annual event that draws teams from all over the Pacific Northwest, as well as hundreds of spectators. (Photograph by John Hough.)

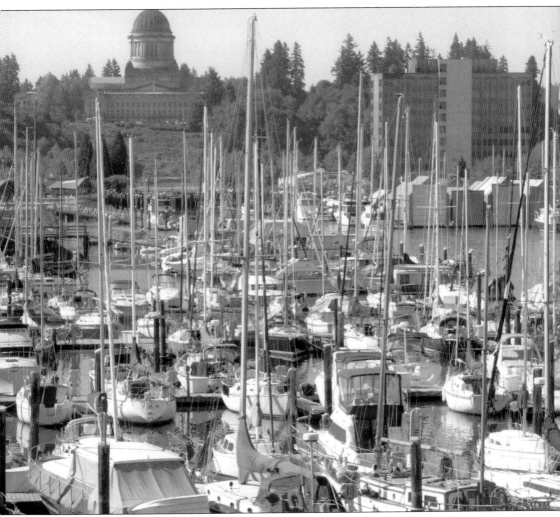

Recreational boating in South Puget Sound is a major economic component of the region's economy. Many boat owners from throughout the region keep their vessels in Olympia for easy access to saltwater cruising throughout Puget Sound and the Salish Sea. (Photograph by John Hough.)

Discover Thousands of Local History Books
Featuring Millions of Vintage Images

Arcadia Publishing, the leading local history publisher in the United States, is committed to making history accessible and meaningful through publishing books that celebrate and preserve the heritage of America's people and places.

Find more books like this at
www.arcadiapublishing.com

Search for your hometown history, your old stomping grounds, and even your favorite sports team.

Consistent with our mission to preserve history on a local level, this book was printed in South Carolina on American-made paper and manufactured entirely in the United States. Products carrying the accredited Forest Stewardship Council (FSC) label are printed on 100 percent FSC-certified paper.

MADE IN THE USA